WATERCOLOR

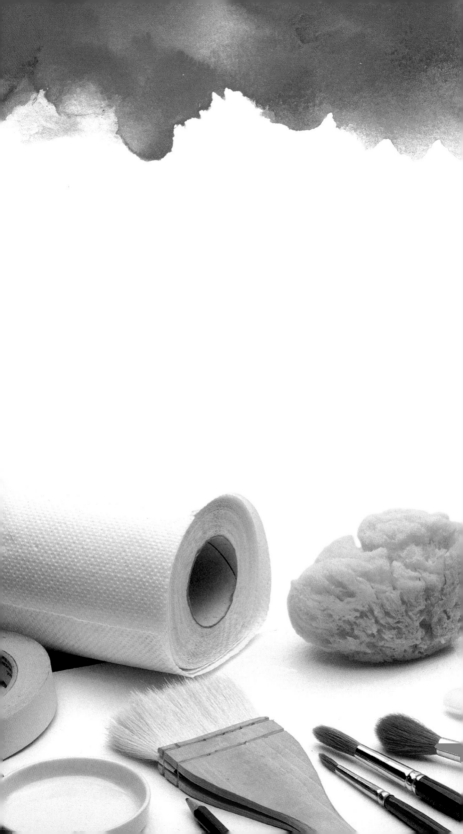

BARRON'S ART HANDBOOKS

WATERCOLOR

BARRON'S

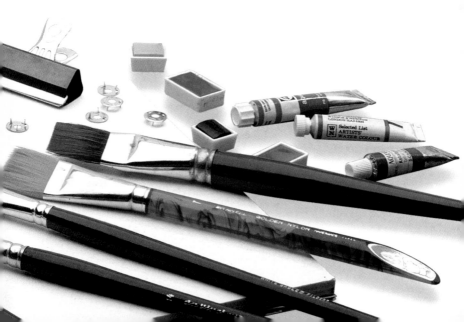

4

CONTENTS

CONTENTS

CONTENTS

BACKGROUND TO WATERCOLOR

Watercolor would appear to be a recent medium, not fully accepted as a painting technique until the end of the eighteenth century. However, if we look back to the earliest times, we see how 3,500 years ago in Egypt, papyrus was painted with transparent colors made out of mineral pigments (cinnabar for red, azurite for blue, malachite for green), earth for ochers and siennas, charcoal for black, and chalk for white. These colors were bound using gum arabic and egg white.

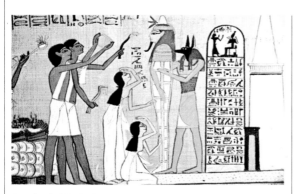

Opening the Mouth of the Mummy of Hunefer, *in The Book of the Dead, 1300 B.C. An illustration on papyrus painted with gum.*

The Earliest Watercolors

In western culture during the ninth century A.D., most miniatures were painted using tempera, an opaque form of watercolor that required egg mixed with white lead. Following the reign of Charlemagne, the miniaturists alternated this opaque watercolor with a transparent version that spread throughout Christendom during the early Middle Ages.

Story of Adam and Eve, *miniature from the manuscript of the Bible of Alcuino. Carolingian period, 834–843. Watercolor on parchment.*

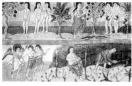

Forerunners

Albrecht Dürer (1471–1528) painted a large number of works during his career (today there are 1,000 drawings, 250 wood engravings, 100 copper engravings and 188 paintings recorded) of which we possess 86 watercolors that reveal an unrivaled technique. The proportion of watercolor to other techniques used in his works show how important Dürer considered this medium.

After Dürer, watercolor went into decline and took second place to oils as a medium. Great artists such as Rubens used small watercolor studies they would later transform into medium-sized oil paintings, after which the apprentices would paint most of the definitive work; the Master would then add the finishing touches.

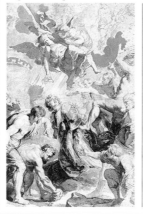

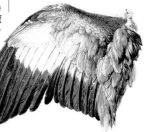

Albrecht Dürer, Bluebird's Wing. Watercolor on parchment.

Albrecht Dürer, View of Kalchreut. Watercolor on paper.

Rubens, *Stoning of Saint Stephen. Preliminary study in watercolor.*

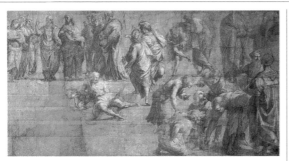

Raphael, The School of Athens. *Study painted in wash. In the illustration below, the finished fresco.*

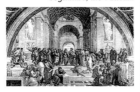

Raphael, The School of Athens. *Fresco painted in the Stanza della Segnatura, the Vatican.*

Watercolors as Studies

From the end of the ninth century to the seventeenth century, watercolors were used as a monochrome technique. In 1390, Cennino Cennini published *Il Libro dell'Arte*, in which he explained the techniques then used.

Watercolor was the medium used by artists in the early stage of their projects. Its tonal gradation was perfectly applied to the monochrome study of light and shadow, before starting on the definitive work. These projects were painted in sepia-colored, monochrome watercolors. Their main purpose was as a point of reference.

Watercolors Regain Color

Around the year 1750, etchings of landscapes for English tourists were a profitable source of income for Italian artists. Canaletto was one of these and his paintings of Venice and Rome were extremely popular with the English public.

These engravings were later enhanced by watercolor, to the extent that color began to take precedence over outline drawing.

The First School of Watercolorists

Toward the end of the eighteenth century, Dr. Monro founded what was to become

the birthplace of British art. He installed tables, chairs, and painting materials in his own home. William Turner was one of the young artists who came to paint there. His work, and his concept of painting in watercolors were entirely modern; his use of light, forms, and space was a landmark in the history of art.

William Turner. Burning of the Houses of Parliament on the Night of 16th October, 1834.

Watercolors as Documents

One of the most common mediums used by botanists and adventure seekers of the eighteenth century was watercolor. Their travel notebooks recorded a wealth of detail about the colors and shapes of different animals and plants. Scientists and botanists would collect images of unknown species during their trips, and these were later engraved in wood to make engraving blocks so they could be reproduced in books.

John Robert Cozens, Cetara, a Fishing Village.

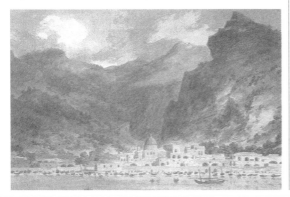

MORE INFORMATION
· The watercolor medium **p. 8**

THE WATERCOLOR MEDIUM

Watercolors dissolve in water and therefore have a series of unique properties that allow the artist to produce works of great chromatic transparency. Watercolors are composed of simple ingredients: it is a mixture that binds together gum arabic and pigment and, when dry, can be made liquid again and used for painting by adding water.

Preparing Watercolors at Home

Watercolors can be prepared at home without too much difficulty. Very few ingredients are needed: just gum arabic, distilled water, pigment, and glass containers.

Neither is it necessary to use a large amount of pigment, as it goes a long way; you only need use a teaspoon of each color you are preparing. The pigment, dampened with distilled water, is placed in small cups shaped like film cartridges. The gum arabic (a lump the size of an egg) is warmed double boiler style inside a glass container and a few drops of glycerin and a tablespoon of distilled water are added to make the gum liquefy. While still hot, a tablespoon of gum arabic is placed into each small container with the pigment and mixed well; the watercolor is now ready.

Masking fluid.

Masking Fluid

Masking fluid is used especially for protecting certain areas of the painting surface. These are the areas we want to leave unpainted in order to create white spaces, or certain shapes that may represent lights or spaces reserved for another color. Masking fluid is applied with a brush and forms a waterproof film when dry that can be removed with the fingers or an eraser.

Medium for Watercolor

This solution of slightly acidic gum is added to the water using a dropper; it eliminates any fatty remains as well as increases the adherence of the water to the paper. When

Medium for watercolor. It increases the adherence and brightness once dry.

Watercolor and Abstract Art

By 1910, Vasili Kandinsky (1866–1944) was painting the first nonobjective paintings in the history of art. These were painted using watercolors, a medium he subsequently employed for a large part of his work.

One of the earliest nonobjective watercolors.

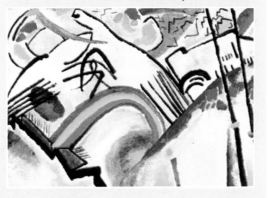

dry, it also makes the colors gleam more brightly.

Wetting Agents

Wetting agents increase the fluidity of the water and color so they can mix together properly. The most suitable agent for watercolor is clarified ox gall. A tablespoonful of this is added for every pint of water.

Wetting agent.

Glycerin

Watercolors dry quickly, which can be a disadvantage when it is hot and the artist wishes to paint over wet. Adding glycerin to the water delays the drying process, enabling artists to take their time.

Glycerin, to slow down the drying.

Alcohol, to speed up the drying.

Alcohol

Whereas glycerin allows the artist to work slowly as it delays the drying process, on occasions the opposite result is desired. When working in a damp atmosphere, or simply to speed up the drying, a drop of 96-proof alcohol will do the job.

Varnishes for Watercolor

These are produced by the major watercolor manufacturers and are used to protect and lend brilliance to the colors. Not all professionals make use of them, but when they are applied in fine layers, they help to revive dark colors that have lost their contrast and luminosity.

MORE INFORMATION

• Watercolor. Abstraction and experimentation **p. 94**

Varnish for watercolor. It provides a brilliant finish.

Water Containers

These containers should hold at least a pint and be wide-necked. They can be made of plastic or glass and one or two are necessary. There are painters who use one container for cleaning the brush after using a color and another for wetting and mixing the paint. Others prefer to use a single container in which the water is stained by all the colors used previously to add chromaticism to the work.

Different containers for water. They should be of sufficient size and be wide-necked.

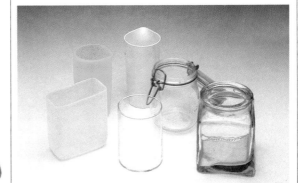

THE STUDIO AND MATERIALS FOR WATERCOLORISTS

Many watercolorists choose to work outdoors, so a large indoor space for a studio is unnecessary. On the other hand, a studio is very useful for the more detailed work that watercolor requires at its late stages. Specific materials are needed, which painters can adapt to their particular needs.

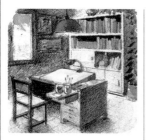

Basic requirements for a watercolorist's studio.

The Studio

Any room in the house can be fitted out as a studio, as watercolor does not require large formats. However, certain basic materials are indispensable such as a table, tabletop easel, side table for the jars of water, a good swing-arm lamp, and folders to store your work.

The ideal studio would require a 12 × 12 foot room with large windows and the following equipment: table, book-

Ideal space for a watercolorist studio.

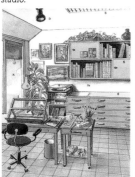

rest, side table on casters, height-adjustable swivel chair, bookshelf, table with flat drawers, music system.

Tables

There are many ways of converting furniture into worktables, the simplest being to place a flat board on two chests of drawers with one side slightly raised to make it easier to work.

More practical, of course, is a typical drawing board which can be fully adjusted. If not much space is available, you can always build your own

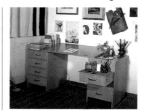

Folding table.

Improvised table with two chests of drawers.

Fully equipped auxiliary table.

practical piece of furniture with all the elements necessary for the watercolorist, i.e. bookrest, side table, tray for paper and an open section for keeping jars and other utensils. Furniture and room sizes frequently depend on the artist's subjective needs.

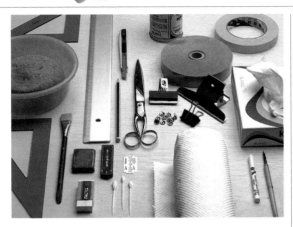

Materials for watercolor painting.

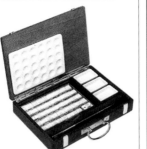

A small traveling paintbox.

Miscellaneous Materials

Aside from basic studio equipment, you should have certain complementary materials to meet all of the watercolorist's requirements.

A number 2 lead pencil for drawing; an ordinary, soft eraser; a metal ruler to assist you when cutting; square and set-square; gummed paper for attaching the paper to the board; Scotch® tape for framing the papers; thumbtacks and clips for stretching the paper on the board. In addition there are other elements, less critical perhaps, but often necessary: white wax for isolating white areas; facial tissues and a roll of absorbent paper; a plate and sponge for squeezing out excess water from the brush; bevel-handled brush for scoring, marking, or opening up white areas on the wet paper; small swab sticks; a scraping tool; pen for India ink; knife for cutting paper; a large pair of scissors and a jar of rubber glue for paper.

A paintbox with watercolors in tubes.

Paintboxes

One of the watercolorist's prize possessions is the paintbox, especially when he or she needs to leave the studio to paint outdoors. There is a wide variety of boxes perfectly designed to accommodate paints, brushes, and palette.

Professional watercolorists generally seek maximal comfort and simplicity when venturing outside to work, such as the box above, which can carry practically all the materials necessary for painting outside the studio.

Painting Space

In this watercolor painted in 1911, *The Model* we can see Sir William Orpen at work in his small London studio. Small rooms are not a hindrance to many artists.

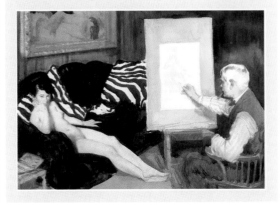

MORE INFORMATION

• The watercolor medium **p. 8**
• Watercolor **p. 12**
• Brushes **p. 18**

WATERCOLOR

Watercolor paintings come in a variety of formats, depending on the needs of the painter in a given situation. This medium comes in a wide range of forms, allowing the artist to choose the density of the watercolor and its packaging. The artist can also choose from a wide variety of portable paintboxes, making this medium easy to use at any time.

Different Formats

Watercolor paints come in four basic formats:
• Pans of dry watercolors; this is an economical form recommended for simple colors such as umbers.

Economical pans.

• Pans of wet watercolors. In this form, the medium has a small amount of glycerin and honey, and is frequently used by professional artists as it dissolves easily. It can be bought loose or in boxes of 6 to 24 colors.
• Tubes of watercolor paints. They contain a pasty form of paint, similar to oil paint, which can be diluted instantly. Of a quality similar to the wet tablets, the tubes are available loose or in palette boxes with

Pans of wet watercolors.

12 colors. Typically, each contains between 8 and 21 ml, that is, less than a fluid ounce.
• Bottles of liquid watercolors. Particularly suited to professionals in the world of design and illustration. They come in screw-top bottles.

Liquid watercolors.

Palette Boxes

This type of box is specially designed for outdoor painting. Such boxes usually take the form of metallic cases with a series of wells for mixing the colors properly. Some fold out,

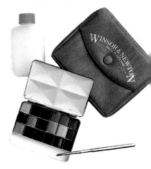

Pocket-size palette box.

for a wider chromatic range and space for palette work. There are also wallet-sized boxes with high-quality watercolors, although they are not very suitable for working in the studio.
They can be used for holding any of the forms of watercolors mentioned above.

Palette box with dry watercolor pans.

Watercolors in tubes.

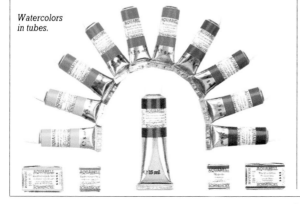

Tempera and Watercolors

Watercolors contain the same ingredients as tempera or wash, the only difference being that tempera contains a larger amount of pigment. Tempera, unlike watercolors, is therefore dense and opaque. It is also

perhaps one of the earliest pictorial mediums ever used; the name tempera comes from the name given to this pictorial technique during the Middle Ages.

Watercolors and tempera contain the same ingredients; the only difference lies in the proportion.

Most Common Colors

The most common colors used for watercolor painting are the following:
- Lemon yellow
- Cadmium yellow medium
- Yellow ochre
- Raw sienna
- Sepia
- Cadmium red
- Alizarin crimson
- Permanent green
- Emerald green
- Cobalt blue
- Ultramarine blue
- Prussian blue
- Payne's gray
- Ivory black

Palette box with an opening for the thumb.

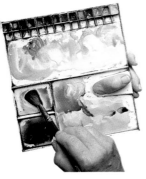

Palettes

The most suitable palette for watercolor and the most used by professional artists is the flat dish type. You can also buy ceramic palettes with different wells for mixing and even plastic ones can be practical as they are light, sturdy, and can be easily cleaned under the faucet.

Disposable plastic palettes can be particularly useful when painting outdoors.

MORE INFORMATION

- The watercolor medium **p. 8**
- Basic watercolor techniques **p. 36**

Lemon yellow

Cadmium yellow medium

Yellow ochre

Raw sienna

Sepia

Cadmium red

Alizarin crimson

Permanent green

Emerald green

Cobalt blue

Ultramarine blue

Prussian blue

Payne's gray

Ivory black

PAPER FOR WATERCOLOR

Paper is, without doubt, one of the most important elements in the art of watercolor painting. Watercolors are soluble in water, so when watercolor is applied to the paper, the pigment opens and penetrates the pores of the paper to be absorbed by the pulp, producing the characteristic transparent color so typical of watercolor paints. Since paper quality is basic and decisive in the outcome of watercolor work, it is important to know about the various types available.

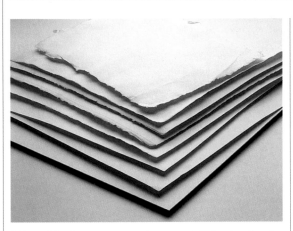

Different grades, often recognizable by their characteristic edges.

cotton, linen, and other vegetable fibers. Pulp for good quality paper is obtained from shredded rags. Nowadays production of handmade paper is on the decline, but this top-quality paper is still the result of painstaking work.

There are also different qualities within each brand range.

Different grades and textures of paper:
1, 2, 3, Fine, medium, and rough.
4, Handmade 120 lb.
5, Arches 300 lb.
6, Fabriano Block.
7, Paperboard.
8, Arches 140 lb.
9, Fabriano 140 lb.
10, Canson 100 lb.
11, Thick deckle edge.

Sides of the Paper

If you look at watercolor paper in Europe, the first thing you will notice is that each side is different, so you can choose which texture you want to paint on. One side will be coarse or medium grain while the other will be medium or fine grain. In the United States both sides are identical.

The thickness of the paper determines how much water will be absorbed and how fine the detail can be. The degree of absorption of the paper also depends on how it has been sized. Heavy sizing helps control the flow of watercolors, but limits the amount of pigment. Lighter sized, more absorbent paper, accepts more pigment, but affords less control over blending of paints.

The Quality of the Paper

There are two different qualities of paper: machine-made paper using cellulose from wood pulp; and the other, of characteristically good quality and made from pulp rich in

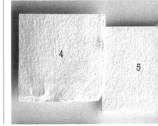

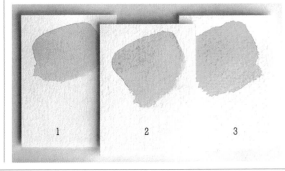

MORE INFORMATION

• Preparing the paper **p. 16**

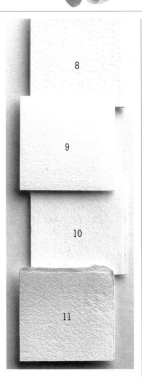

Unit for Measuring Paper

Paper is measured in reams. A ream is 500 sheets. The weight of the ream is determined by the paper's thickness and dimensions. A moderate 22 x 30 inch paper weighs 140 lb.; a thick paper of the same size weighs 300 lb. and resembles paperboard.

from, irrespective of the brand:

• Fine grain paper is hot pressed and has a practically smooth surface. It is particularly suited for watercolorists carrying out delicate work, such as illustrators.

• Medium grain paper is the least problematic. It is medium rough, cold press paper, suitable for all kinds of painting. Using it you will avoid "paint puddles" on its surface.

• Rough grain paper. Its texture absorbs the water and delays the drying time. Highly prized by professional artists but difficult to use for beginners.

There are differences, of course, related to texture and sizing, between the brands in each quality. Depending on the amount of size, the paper absorbs more or less water.

Brands and Formats

Paper for watercolor can be bought by the sheet or in pads. Below are some brands and qualities used by watercolorists: Handmade Arches, cold press, hot press, and rough, 90–300 lb.; Arches block; handmade Fabriano Esportazione 90 lb.; Fabriano block; handmade Wahtman; Canson block 80–140 lb.; Winsor and Newton block 90 lb.

Popular sheet sizes in the United States are 22 × 30 and 26 × 42 inches. Blocks range in size from 7 × 10 to 18 × 24 inches. In the United Kingdom, the most common sizes are the Imperial 22 × 30, Double Elephant 27 × 40, and Antiquarian 31 × 53 inches.

Different brands of paper are also sold in blocks, glued on four sides, for stability against warping or cockling. To separate the paper from the block, carefully remove it with a knife.

Manufacturer's stamp.

Different brands and formats in blocks.

Top quality paper is usually expensive, so the manufacturers sell paper that is not so pure but still perfectly suitable for watercolor painting.

Grain, Gum, and Texture

Starting with the fact that, to paint properly in watercolor you need professional quality paper, there are three different qualities of grain to choose

PREPARING THE PAPER

Watercolor is a wet medium used on a paper surface that is flat and smooth after being manufactured. When it becomes wet, however, it warps and puckers. Therefore, if you paint in watercolors on paper that is not taut, it will wrinkle on contact with the water. This can be avoided by stretching the paper. Several methods can be used for this.

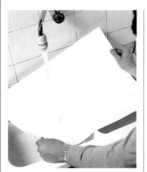

The paper should first be completely wet to open up the pores.

Wetting the Paper

Preparing paper for painting in watercolors is a simple but rather time-consuming operation, so it must be done with care and patience.

In order to tauten the paper, first it must expand, and the easiest way to do this is to wet it under the faucet or with a sponge. The paper is not degraded by the water; the fiber simply absorbs it and dilates.

Attaching the Paper to a Rigid Surface

Once the paper is sufficiently wet, any excess water is removed using a sponge or two pieces of blotting paper. The aim here is not to dry it, but simply to ensure that it is not dripping wet.

The paper is then placed on a flat board. It is useful to have several such boards for use as a rigid support. For painting landscapes outside the studio, it is always convenient to have

The paper must be laid completely flat on the board or surface you are going to use.

a panel the size of the folder to make it easier to carry.

Gummed Tape

Gummed tape is a strip of rolled paper with a layer of gum arabic on one side. When the tape is moistened with a sponge, the gum softens and becomes adhesive and so it is very useful for attaching the paper to the board.

Be sure you cut strips of gummed paper slightly longer than the length and width of the paper to be attached. The first strip is wet with a sponge and placed along one of the sides of the paper, pressing down

and making sure it sticks to the board. The remaining three are placed in the same way.

The gum arabic will dry before the paper does and will adhere to the board. In this way, when the water evaporates from the paper and it dries out, the contracting fibers will tauten the paper.

The adhesive tape attaches the paper to the board before it dries out and shrinks back to its original size.

After attaching the first side, do the same with the opposite, and then the other two.

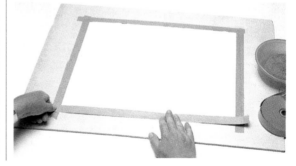

Attaching the Paper to the Stretcher

This system is not commonly used, but will produce a taut surface even for the largest formats.

Before wetting the paper, wedge-shaped cuts must be made around the perimeter of the paper. It is then placed under the stretcher, which should always be smaller than the sur-

Wetting the paper with a sponge.

Folding the wet paper over the edge of the stretcher.

face of the paper, so the edges of the paper can be folded around the strecher's edges.

Once the stretcher is placed on the paper, the flaps are gummed and folded onto the stretcher. When dry, it will be taut like the skin of a drum.

Body and Texture

Texture and body can be added to taut paper by applying sealer.

With the paper taut on the stretcher, one or more layers of sealer are applied to fill the pores. Varnishing paper is only advisable when you want to achieve a particular effect, so it is useful to carry out tests with paint once the paper has been treated.

Other Methods of Attaching the Paper

It is not always necessary to attach the paper using adhesive tape. Other fast and equally effective methods can be used, especially for heavy grade paper. Stapling is one of the most common methods, and the procedure is the same as for tape, leaving a 2-inch gap between staples.

If you are going to use really heavy paper, just attach the paper to the board with thumbtacks or metal clips.

The paper can be attached with staples before it dries.

Metal clips can be used for thick paper.

MORE INFORMATION

• Paper for watercolor **p. 14**

Paper attached with thumbtacks. When dry it will be smooth and taut.

SURFACES, MATERIALS, AND TOOLS

BRUSHES

If brushes are of great importance in other mediums, such as oils, they are even more so when it comes to watercolor. The brush leaves a particular mark in thick paints, such as oil paints, and this mark can be altered or even totally concealed by later brushwork, as the layer of paint is thick and dense. In watercolor, this layer has no thickness whatsoever and, in addition, is totally transparent. This characteristic of watercolor, together with the fact that it is a water-based medium, requires a certain type of brush to alternate the softness of the brushstroke and the capacity to absorb and apply water on the paper.

Worn Brushes

Watercolor painting may require more than soft, delicate brushes.

Selection depends largely on the artist's temperament and the kind of work one wants to do. Sometimes an old, worn brush is perfectly suitable in watercolor for drawing (as it absorbs little water) or for rubbing the paper with the brush almost dry.

A set of brushes for different techniques such as *frottage*, painting on dry or on wet, scraping, full wetting, etc. could be the following: a French *putois* brush with very thick fitch hair; a wide flat brush for large areas; filbert

Worn brushes can produce interesting effects, for they not only leave a characteristic mark but also absorb less water and are therefore ideal for frottage.

oxhair brushes, one wide and one medium; a worn bristle brush such as those used for oil painting will serve for drawing, rubbing, or *frottage*.

Sable Hair Brushes

Sable hair brushes are the most highly esteemed by professional watercolorists. They are made from the tail of the Kolinsky breed, which comes from Russia and China. Extremely soft and capable of holding a very large quantity of water, they are very time-consuming to manufacture and are therefore expensive. For this reason, some manufacturers of high quality brushes also produce medium quality products that combine red sable hair and ox hair.

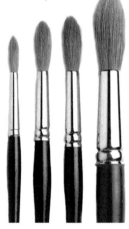

A minimal assortment of brushes for watercolor painting: three are sable hair and the thickest, ox hair.

Brush Quality

Even a good quality brush will eventually deteriorate over time. The main requirements of a good brush are its capacity to absorb water and color; flexibility to respond to the slightest pressure; and spring, meaning a brush that resumes its initial shape and a perfect tip however hard it has been applied to the paper.

After the sable brush, and from greater to lesser quality, there are mongoose brushes, red squirrel brushes, and lastly ox hair brushes.

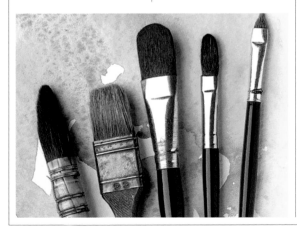

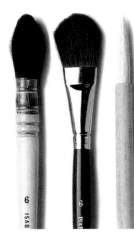

Other Brushes and Accessories

In artists' supply stores you can find a wide range of Japanese brushes of acceptable quality, above all the flat and wide brushes that are particularly suitable for painting in wash and for staining large areas.

Synthetic brushes are also of acceptable quality and, although not so good as sable hair brushes, usually provide highly satisfactory results.

In addition to the brushes you need a sponge roller and a natural sponge for absorbing, creating texture, and so on.

An assortment of the brushes most commonly used by watercolorists.

Three complementary items for watercolor painting: a Chinese-type brush with great water retention capability, a plastic foam roller, and a natural sponge.

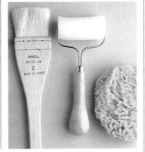

The Most Commonly Used Brushes

Out of the wide range of brushes available, a good collection would be as follows:

Two squirrel hair brushes, used especially for backgrounds and gradations; a couple of Japanese brushes for drawing and for painting in thick, steady brushstrokes; a couple of simple, medium quality synthetic brushes; a fine mongoose hair brush; a special brush for fine lines; a fan-shaped brush, for blending colors; two bristle brushes such as those used in oils, one a filbert and the other a flat type.

How Brushes Are Numbered

Watercolor brushes come in different thicknesses numbered from 00; 1 to 14 for sable hair brushes and up to 24 for ox hair brushes. The number of the brush is shown on the handle.

An assortment of sable hair brushes.

MORE INFORMATION

• The studio and materials for watercolorists **p. 10**

THE WASH, A PREPARATORY TECHNIQUE

Wash is located halfway between drawing and watercolor. This technique includes elements of drawing such as tonal value and use of monochrome, yet it is applied with a brush, producing lines and expression that are characteristic of watercolor painting. It is often difficult to distinguish where drawing ends and painting starts, and in this case it is even more so. Wherever one technique takes over from the other, wash is certainly a preparatory technique to watercolor.

What Is a Wash?

A wash uses the white of the paper as the most luminous color. This technique requires drawing and painting in one or two colors diluted in water to produce an entire range of transparent tonal values, that is, tonal glazes that are super-imposed, heightening the tone of the color or allowing the background color to shine through the tonal contrast.

Glaze starts by using the white of the paper as the basis for a monochrome treatment used to study the tonal value of the objects

Preparing a Wash

The basis of wash is water. This being monochromatic painting, the starting color is obviously of little importance since the gradation of that color is what the tonal value is based on.

On the palette (or plate) place a small amount of water-color; of course, the more water is added, the lighter the resulting tone. This shows how the transparency of watercolors is increased by adding water until the background color of the paper highlights through, and explains the rationale of never using white in watercolor since maximal whiteness is provided by the paper itself.

A Practice Session

To understand how the wash technique works in practice, draw a cube in perspective and prepare an initial glaze to paint the two shaded sides. When they are dry, the dark-est one should be repainted using the same glaze and the two tones will reinforce each other. The upper face is then lightly painted and, before it has time to dry, water is added with the brush, blending the color and using a dry brush to absorb excess moisture.

Different tones in wash: the greater the amount of water, the more transparent the resulting color.

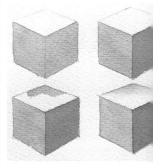

How to paint a cube in wash. The sum of two tones produces a third, darker tone.

Wash as Watercolor

Wash uses the same technique as watercolor. The artist can apply it in as many different ways as desired, in this case, working over an elaborate drawing with a very free brush. When dry, two tones were then used: one light and wet for the sky and a darker, dry tone for the buildings, leaving the underlying drawing still visible.

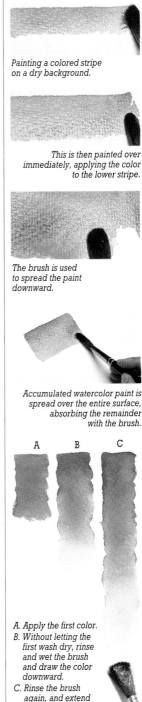

Painting a colored stripe on a dry background.

This is then painted over immediately, applying the color to the lower stripe.

The brush is used to spread the paint downward.

Accumulated watercolor paint is spread over the entire surface, absorbing the remainder with the brush.

A B C

Wash Using Two Colors

A wide range of tonalities can be obtained using two colors, as watercolors not only shade the color itself, but also the transparency of the color.

Wash can also be applied using two colors. If you paint with burnt sienna and cobalt blue, you can obtain a really wide range of tones and intensities, with warm and cold hues. In the same way a color can be diluted to bring out its tonal qualities, you can do the same with two colors. However, you must mix them before diluting in order to start with an intense tone and not have an insipid look.

Wash in Practice

In order to become familiar with the use of wash and, by extension, watercolor, it is important to master the following techniques:
• To paint an area a uniform color, the brush is soaked in wash and drawn horizontally across the paper, always starting at the top because, as the paper is tilted, the wash tends to accumulate in the lower area. This operation is then repeated, the brush is again loaded with paint and a new stripe is painted, which draws across the water accumulated earlier. If there is too much paint, the brush is applied vertically, spreading the paint over the entire area. If paint has accumulated at the edges, a squeezed out sponge is used to absorb any excess.
• To paint gradations, a small area is painted first and the brush is rinsed out. Using this clean brush, the end of the stripe is wetted, moving downward, alternating the rinse and the spread of the paint.

A. Apply the first color.
B. Without letting the first wash dry, rinse and wet the brush and draw the color downward.
C. Rinse the brush again, and extend the color farther downward.

WATERCOLOR AND WASH

A knowledge of color theory and of how to paint in wash is a prerequisite for watercolor painting. Apart from this, there is also a series of techniques that, with practice, make watercolor painting come more easily. In the last chapter we outlined the wash technique and now we will approach watercolor applying all these techniques together.

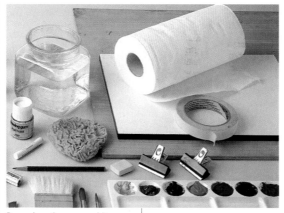

Paper, board, sponge, white wax, pencil, and water are the essential elements for wash.

Necessary Materials

Not as many materials are necessary to paint in wash as for watercolor because only one or two colors are used. In this case, we shall use thick rather than fine paper so as not to have to attach it; we shall also need a board, two sable brushes (numbers 8 and 14), a wide brush, a sponge, and a jar of water.

Dry Wash

The word *wash* refers to wetting the paper with paint. The wetting can be done on wet or dry paper.

In the dry wash you take a piece of paper and draw elongated rectangles in pencil. The dry washes are painted to check the transparency and gradation potential of the watercolor. The first wash is with a dark tone, diluted just enough for the color to be transparent.

Slightly more water and slightly less paint are used in the next wash, until the other two tones are obtained, trying to make each uniform and the amount of water just right; it is better to add too much than too little water.

Each tone has been diluted by increasing the amount of water.

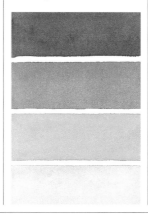

Gradation on Wet

As opposed to dry wash, in the wet technique the area you are going to paint must be dampened first, gently dabbing it with a sponge so as not to spoil the surface of the paper.

When working in watercolors, the paper should always be slightly tilted as this makes it easier to apply the paint.

With the brush loaded with paint and a small amount of water, you begin at the top by quickly painting a series of horizontal stripes, gradually using less paint for each one. As the paper is damp, the paint will spread easily, so you must be careful not to spoil the evenly gradated area.

1. You start by painting a strong colored stripe from side to side of the paper.

2. By pressing down on the brush to release clean water, part of the original stripe is brought farther down.

3. Once the brush has been rinsed, it is squeezed dry and drawn across part of the earlier gradation.

Gradation with a Sponge

In watercolor painting, a sponge can produce results just as good as those obtained using the best paintbrush, especially if you are familiar with the technique.

In the same way that you can obtain gradations on wet using a brush, a sponge can be used, which is a somewhat simpler technique, although care should be taken that the paper does not dry out.

A colored wash should be prepared beforehand on a saucer.

Once the paper has been wetted with clean water, the sponge is dipped in the paint and horizontal lines are painted beginning at the top.

Once the sponge has gone over the upper half of the paper, it should then be rinsed

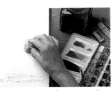

1. Wetting the area in preparation for the gradations.

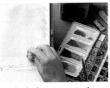

2. The paint is drawn across the wet surface using a sponge filled with color.

3. With the sponge squeezed out and wet in clean water, it is drawn again horizontally across the paper, taking the color downward.

and, after squeezing out any excess water, the color is drawn down the paper to the lower half, cleaning the sponge to remove some of the color as you work downward.

Opening up White Spaces

As we mentioned, the color white is not used, as this is provided by the white of the paper.

To open up a white space on a wet surface, clean and dry the brush, as this will be used in the same way as a sponge, to absorb the water.

When the wash is dry, this process becomes more time-consuming. The brush should be wetted in clean water and the area dampened, constantly cleaning the brush and repeating the operation until the paint starts to dissolve.

Blotting paper is then used to remove the dampness and the process is repeated.

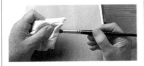

Opening up a white area on the wet surface

An Economical Technique

Both wash and watercolor are techniques that require time and dedication. Yet all the great artists have learned them, often out of necessity. Most painters have had to resort to the most economical techniques available, as they could not always afford a stretcher, canvas, and oils. That was why in Paris at the beginning of the twentieth century, different, successive schools of avant-garde painting left behind a vast production of watercolors.

Paul Cézanne, The Boy in the Red Vest. The avant-garde artists resorted to watercolors as they were economical and the results were immediate.

Opening whites on a dry surface.

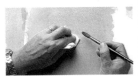

MORE INFORMATION

- The wash, a preparatory technique **p. 20**
- Synthesizing forms **p. 24**
- The still life: gradation and light in simple elements **p. 42**

SYNTHESIZING FORMS

With any other pictorial medium you have to start from scratch. There is no use in attempting to produce a complex picture in a medium you are not familiar with. Even when you feel you have sufficiently mastered the medium it is always good to review basics because you will find that you can get new ideas.

Watercolor is a highly transparent and luminous medium. While these characteristics allow you to achieve effects of outstanding plastic richness, the techniques to obtain them are somewhat more complex than those of other pictorial mediums.

Geometric Bodies, the Sphere

All objects in nature can be reduced to basic geometric forms. It is therefore essential to practice painting these shapes in order to obtain a firm grasp of the watercolor medium.

Round-shaped volumes can be reduced to a sphere; it is best to begin with a rough drawing of the object and its shadow, a circle over an oval. The oval shows the plane the sphere is situated on.

Before the paint has time to dry, paint the darker color of the shadowed surface area and, without cleaning the brush, only dipping it in water, give it a spherical

Using these geometric shapes, it is possible to synthesize any object.

Blending Color

First you dampen the entire surface of the sphere with a sponge, with the exception of the circle to be highlighted. Immediately after, put a layer of very pale watercolor on the whole area except the highlight, creating a clean gradation between it and the general surface.

After the drawing, a general staining of the shadows is carried out without going over the line separating it from the original colors.

shape. Blend the color reserving the shiniest parts.

Once the sphere is dry, the zone of shadow is painted with a darker color than that of the underside of the sphere, taking advantage of the wetness to gradate the color toward the lightest part of the shadow.

When the entire surface of the paper is dry, you can heighten the tonalities of the shadows without fear of the paint running.

The color has been blended with the background.

The Layout and the Drawing

As you can see, the drawing forms the basic outline for a watercolor. Therefore a correct layout is essential, since this medium does not allow the artist to make changes with paint on the initial structure.

Regardless of what the subject is, all watercolor projects must first be sketched in pencil, without shadows.

The contrasts in the shadows have been heightened.

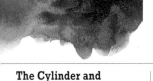

The Cylinder and the Cube

Here we are going to make a bicolor set of two geometric shapes. Once you have drawn the initial layout and the elements have been situated in perspective and their shadows resolved, paint the cube's two visible faces and their shadows in a very diluted green. Now wash the brush and use it to wet the surface of the cylinder. Finally, apply vertical brushwork in blue to paint the darkest part of the cylinder and create a gradation toward the zone of maximal luminosity.

After the initial layout, the first tones and a soft gradation in blue are laid on the cylinder.

Alternating Wet Over Dry

The technique of applying wet paint over a lower layer that has dried is very common in watercolor.

Lightly wet the brush in clean water and, without color, apply it over the top of the cube and its darkest side. Now, using the same green tone you used before, paint the darkest zone in a uniform fashion, and create a subtle gradation toward the white of the paper on the top. Once the paint has dried the blue will appear more intense in the volume nearest the viewer. Last, wet the darkest zone at

When the first wash is dry, a darker one is added.

the top of the cylinder with a light wash.

The Last Gradation

With a rinsed brush, while the paint is still wet, grade the cylinder by carrying color with soft brushstrokes up to the lightest part.

When completely dry, nuance the shadows with a touch of paint on an almost dry brush and darken the zones nearest the brightest ones.

A gradation is put over the previous glaze, darkening the shaded greens.

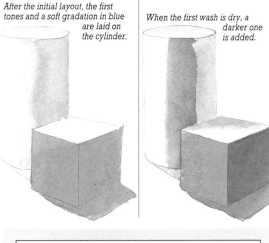

Geometry and Synthesis

Everything can be reduced to geometric forms, but the shape may vary with the color. Therefore, the technique of alternating dry color on wet color and vice versa helps to establish the texture of the object in question. Organic elements tend to possess surfaces that are rich in tones, hues, highlights, and even lines of definition.

All elements can be reduced to simple forms.

MORE INFORMATION

• The wash, a preparatory technique **p. 20**
• Watercolor and wash **p. 22**
• The still life: gradation and light in simple elements **p. 42**

COLOR THEORY APPLIED TO WATERCOLOR

In theory, watercolor may seem easy to master. In practice, watercolor can be as difficult as the painter wants this medium to be. Indeed, many professionals find it so challenging and with such a vast number of plastic possibilities that they make it their medium of choice. In opaque pictorial mediums, color mixes are carried out on the palette, and the color applied to the painting covers the underlying ones. This is not so in watercolor, whose transparent nature makes the colors appear through successive layers in a manner similar to superimposed stained glass, which means that the painter must concentrate on mixing colors on the palette and mixing them on the painting surface.

All Colors Derive from Three

Watercolor painting does not require many colors to handle the entire chromatic range. Due to the transparent and fluid nature of the colors, the chromatic intensity can be altered simply by adding more water.

The three primary colors are blue, red, and yellow. By mixing these colors together the secondary colors are obtained: red and yellow produce orange; yellow and blue produce green, and last, blue plus red creates violet.

By mixing the primary and secondary colors together, the tertiary or neutral colors are obtained: green and yellow form pale green; green and blue produce greenish blue; red and

All other colors can be obtained from these.

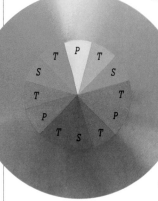

The color variations can be distinguished in this color wheel. P corresponds to primary colors, S to secondary colors, and T to the tertiary colors.

White Is Absent in Watercolor

Watercolor is a transparent and watery medium, which means that white is not needed to create mixes. Highlights and transitions in tone are created by means of the white of the paper together with washes of varying degrees of brightness.

The transparency of watercolor is due to its watery medium.

Landscape painted with blue, purple, yellow, and black.

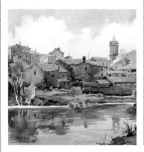

green give us gray. Any two opposites of the color wheel are complementary. The complementary pairs are composed of one primary and one secondary color.

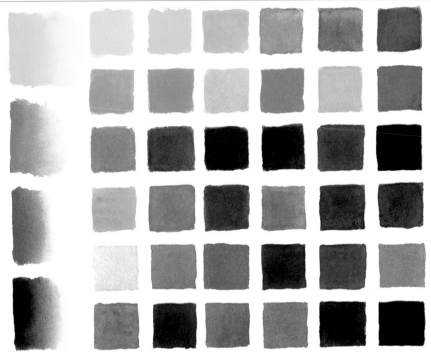

A wide range of colors obtained from mixing together the three primary colors plus black.

The brightness of a color depends exclusively on the background color, that is, the color of the paper.

Checking the Color

Color in watercolor is an extremely delicate subject. Therefore, before you apply it to the paper, it is essential to be sure that it is the right color. The best way to do this is to wet the brush over the color and place it on the palette. Place the color you wish to mix in another area of the palette and carry out the mix in a third compartment. Then test the result on a piece of the same type of paper that you are going to use for your definitive painting.

The Entire Range

The three primary colors and black are enough to paint any color found in nature. Here we have created only 36 different colors.

MORE INFORMATION

- Advanced techniques and effects **p. 38**
- Glazes in still lifes **p. 52**
- Chromaticism and depth **p. 64**

GREAT WATERCOLOR THEMES

Watercolor painting is suitable for any type of theme. In fact, throughout art history, the great masters have exploited this medium to paint both landscapes and still lifes and even portraits, although the complexity involved in the latter has not made it a very popular subject in the watercolor medium.

Albrecht Dürer, View of Arc. *By the fifteenth century the landscape was already one of the most important motifs.*

Thomas Guirtin, Waterfalls at Cayne. *During the eighteenth century, the virtuosity of the English school created landscapes of great sensitivity.*

Watercolor and the Landscape

Watercolor has always been the landscape painter's favorite medium. On the one hand, the painter does not have to carry a lot of materials and accessories around; a small note pad and a small paint set are enough for painting a scene in the middle of the countryside. On the other hand, the speedy drying allows the artist to work fast.

Without doubt the landscape has been the one motif that has favored the development of this medium independently of

pictorial style. Even when watercolor was still not regarded as a medium separate from oil, painters did not hesitate to make use of it for capturing scenes in color notes and sketches. It was not until Romanticism that artists began to proudly display their watercolors as definitive works and not merely studies.

Watercolor and Still Life

Within the realm of figurative painting the still life is one of the subjects most developed by all.

Watercolor favors the understanding of forms and masses of color, as well as the relationship established between the background and the figure. The watercolor medium demands an emphasis on the synthesis of form and color; being a transparent medium,

objects and chromaticism establish a particularly interdependent relationship. The still life in watercolor is a fundamental exercise for understanding forms in space and seeing how light acts on each object represented.

In short, painting a still life allows you to assess your progress either in terms of watercolor techniques or the interpretation of different themes.

Guillem Fresquet, Still Life. *The still life is one of the most common themes in watercolor.*

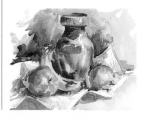

MORE INFORMATION

• The still life: gradation and light in simple elements **p. 42**
• Developing a watercolor in practice: the landscape **p. 54**
• The nude **p. 82**
• The portrait **p. 92**

The Portrait as a Challenge

Although the portrait is not entirely incompatible with the watercolor medium, it is common knowledge that a portrait in watercolors is a challenge that many artists refuse to take up.

The reason for this is that a portrait painted in watercolors requires time and skill. However, many great painters have demonstrated their mastery by making portraits of exceptional quality in watercolors, thus

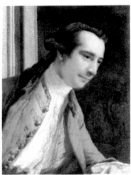

Francis Cotes, Portrait of Paul. The portrait poses the greatest challenge of all to the watercolorist.

proving that creativity knows no boundaries.

The Foundation of Watercolor

A good watercolorist must know how to draw properly because watercolor hides nothing. The drawing forms the structural base of a watercolor painting and it is this schema that allows the painter to developed his theme.

The Nude in Watercolor

Rendering of a model demands facile brushwork of the type that can only be achieved with watercolor, either by fast or direct painting or through long meticulous work sessions. Due to its transparency, water-

Abstract Painting

Each era brings forth its styles and artists. At present it is difficult to pinpoint any reigning style in painting; all creative possibilities are employed in both abstract and figurative work.

Since the time Kandinisky first executed an abstract watercolor, painters have used the watercolor medium to convey the expression of aesthetic feeling.

Watercolor allows all manner of transmutations and subtleties, atmospheric spaces, and pure abstraction. Although the abstract work of any artist is often more spontaneous and pleasing than certain vain efforts of figurative representation, abstract watercolor art is not easy. Picasso would say that before destroying anything, one should know how to construct it.

color can produce subtle glazes in the flesh colors and allows intense contrasts to be obtained. Furthermore, the possibilities of working on wet and on dry make this medium an indispensable tool for sketching and painting the model.

It is essential to master drawing in order to paint a nude.

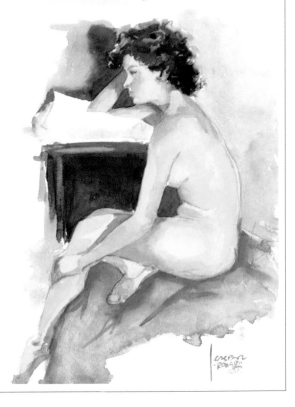

DRAWING, THE FOUNDATION OF WATERCOLOR. THE STILL LIFE

The watercolor is the most "sincere" medium, that is to say, due to its transparency, the paint cannot hide the picture's initial structure drawn in pencil. Thus the drawing technique employed in watercolor painting differs somewhat from that used in other pictorial mediums. Since there is no way of masking the drawing, the pencil lines have to be concise but completely explicative, without shadows, but establishing the spaces where the shadows should be.

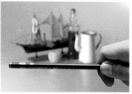

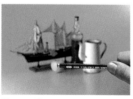

The pencil serves as a measure for putting proportions onto the paper.

The Object within the Picture Space and its Proportions

All objects take up an area in space. The object and part of the space around it can be transferred onto the single plane of the paper.

The proportions of the different parts of a subject that we wish to draw can be determined by measuring a distance in the subject and establishing relationships with the whole. For instance, to establish the proportions of a vase of flowers, we would first measure the height of the vase with the pencil and then use it to establish the position and size of the elements of the whole. That is, if the jar measures A, we can establish that the total size of the painting is twice A. This same method is used to work out the proportion of the flowers.

Boxing the Form

All shapes, even the most complex ones, can be reduced to a simple geometric shape. It all boils down to boxing the object within some simple lines that define the space within which the object stands. These lines must be concise, since they play a decisive role in the subsequent development of the work and the construction of the forms within it.

In this or any other model,

All bodies can be boxed within simple geometric shapes.

The structure between the distances of the model's different elements can be understood with a schematic drawing.

vertical and horizontal lines can be imagined that pass through the reference points and allow you to situate and proportion forms.

Another aid for calculating sizes and proportions is to learn to see the space that surrounds the model as an individual element in the picture, and include this new proportion in your placement of your subject's real shapes.

Imagining the solid shapes in open spaces (a,b,c) is another way of measuring sizes and proportions.

a

b

c

The Simple Reference Drawing

Once you have correctly situated the different forms of the model within the space you have assigned to it, you will have at your disposal a good reference for the proportions and can rework the lines for the internal structure of what you are picturing.

Unlike the drawings used for paintings executed in oils or pastels, the watercolor drawing has to completely ignore the inclusion of shadows. However, it can be useful to draw a separate study including shadows and a scale of grays, because this allows the painter to situate the model within the space.

A schematic drawing before value allocation.

A separate tonal evaluation allows the artist to understand the colors of the model better.

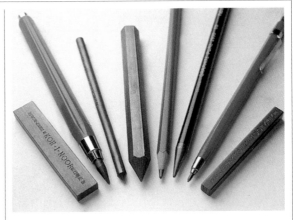

Different types of pencils.

The Clear Line

With watercolor, the line has to be clean and clear, since it determines zones where color will be added; anything other than the most essential lines should be disregarded. The best way of understanding the space in both a still life and any other theme you want to capture is by regular drawing practice.

The reason for such extreme clarity is to avoid losing oneself while making transparent masses of color. Going about it in this way ensures you will obtain a balanced drawing, clearly defining all the objects that are to be included in the picture.

Of course, you will need some materials to carry out your work; starting with a number 2 pencil.

Drawing and Expression

Regardless of the degree of synthesis reached in any painting, drawing is fundamental in the development of a watercolor.

In this still life with the four main elements situated on a plane, the underlying drawing still plays a predominant role even in the expressive brushwork.

Manel Plana, Still Life.

MORE INFORMATION

• Synthesizing forms **p. 24**
• Still life: the model **p. 44**

A good exercise consists of drawing whatever you see in front of you in as clean and clear a manner as possible. It is the best way to start developing a watercolor.

FIT AND BALANCE

Regardless of the medium we are working with, all themes have to be composed, framed, and boxed in order to find the most appropriate composition. However, there are some variations in the way we go about these three procedures, depending on the medium we are going to use and the part of the theme we wish to emphasize. Furthermore, variations of the treatment of these three procedures with the same model and medium may produce totally different results.

Framing

Once you have chosen the model, you are faced with a dilemma. What part of the model will you choose? How will you situate the model on the paper? The motif should not pose an obstacle between reality and its representation; on the contrary, the model is

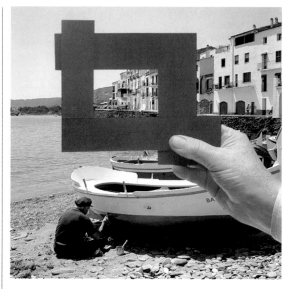

A completely symmetrical composition appears monotonous because of its lack of variation.

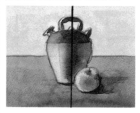

used to transfer the third dimension of reality onto the paper. Nonetheless, you should not be frightened of choosing the fit. The way in which you select the part that you wish to show consists in determining which parts detract from the

Moving the painting's elements to one side breaks the monotony but leaves the painting unbalanced.

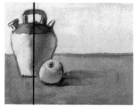

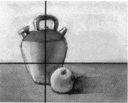

The balance has been achieved by a correct distribution of the elements. The center of attention has been moved slightly toward the left.

picture's center of interest. Therefore, it is best to first locate a focal point, concentrating your view on it, and leaving out anything that might distract the spectator's attention.

The cardboard frame is a useful tool to determine the best fit.

Useful Tool

A useful device to have handy for obtaining the correct fit is a cardboard frame, which helps in sectioning the subject you have chosen.

Such a frame is easy to make: cut out two L-shaped pieces of cardboard painted black or covered with black paper. They should measure about 18 inches in width.

The viewfinder is simple to use. Superimpose one L on another to get an elongated or horizontal sighting. Look through it with one eye closed to determine the most interesting portion of your subject. Then make notes and sketch your composition.

The Rule of the Golden Section

To find the division of the golden section, multiply the total length of the space by the factor 0.618. The rule of the golden section can be applied both to the height and to the width of the painting. Where both sections cross, they form the golden point, considered the ideal place to situate the painting's main figure.

The various fits chosen may differ greatly.

Plato's Legacy

Beauty, according to Plato, is anything that is pleasing to the eye. But how can the elements in a painting be arranged to achieve a satisfactory whole? There is no concrete answer to this question, only norms like Plato's that provide us with some guidance.

First find and represent the variety within unity. If there is too much unity, as when, the picture appears compressed, color and shape provide little variety, and you have an uninteresting and monotonous view.

On the other hand, if there is too much variety, the color and the

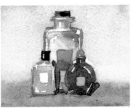

In this frame the objects are too crowded. Not advisable.

shape differ so much that the unity among the picture's elements is lost, and this dispersion may appear very unpleasant to the spectator. The application of Plato's rule of variety within unity provides us with a harmonious diversity of form and color, neither monotonous nor a hodge-podge.

The Golden Section

This architectural rule of Roman origin was devised to lo-

This placement of the elements gives a sense of balance.

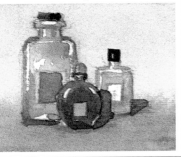

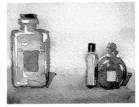

Here the objects are too dispersed; avoid such an arrangement.

cate the ideal arrangement of elements within an enclosed space. The Golden Section stated, that for an area divided into sections to be agreeable and aesthetic, there should exist the same relationship between the larger section and the whole as between the smaller and larger sections.

This rule sought to locate the ideal point of balance in a picture. A completely symmetrical composition lacks interest, a completely asymmetrical composition produces imbalance, while a perfect balance is obtained by putting the rule of the golden section into practice.

MORE INFORMATION

• Compositional schemes and situation of planes **p. 34**
• Superimposing planes in watercolor **p. 68**

TECHNIQUE AND PRACTICE

COMPOSITIONAL SCHEMES AND SITUATION OF PLANES

The composition consists of distributing the model´s different elements on the picture area available. There is no unique compositional formula, since the weights and masses can be arranged in an infinite number of ways. Nonetheless, there are several compositional techniques for ensuring a correct balance.

Composition is not purely a question of aesthetics, it also involves creating planes to provide the spectator with the illusion of a three-dimensional representation.

Triangular composition.

L-shaped composition.

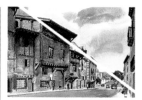

Diagonal composition.

Types of Composition

As we have already mentioned, all elements can be reduced to basic geometric shapes; therefore, we should arrange these shapes in the most harmonious way.

Composition can be defined as the search for beauty in balance. Among the numerous possible compositions there are few perfectly symmetrical ones; in fact, the vast majority are asymmetrical. But this does not mean that you cannot use a symmetrical composition.

The triangle, the L, the zigzag, the diagonal, or elliptic are just a few of the possible compositional schemes that can be employed in a painting.

Elliptical composition.

Zig-zag composition.

Painting a Well-Defined Foreground

When choosing the right composition one should consider those elements that will be useful to create depth.

By including one or several objects whose size and dimensions we are familiar with creates the idea of distance between the foreground and the rest of the planes in the painting.

Other planes recede when the foreground is emphasized.

Color and Composition

The compositional elements are not the only features that indicate distance. See, in this painting, how warm colors are used in the foreground against cooler colors of the more distant planes. Warm colors in the foreground always make the plane appear to "approach" the spectator.

Martínez Lozano,
Fishing Harbor.

Superimposing Successive Planes

Planes allow the artist to represent the sensation of the third dimension. A highly effective form of depth is obtained by the superimposition of successive planes. That is to say, one should include certain elements in each of the different planes.

Note the example illustrated on this page. The foreground contains several houses, the middle ground has the village and the background, a monastery. This method of successive superimposed planes can be applied to all themes.

Superimposition of planes creates a three-dimensional effect.

Perspective

If you wish to paint a picture whose depth is not created by means of successive planes but by lines that converge at the center of interest, you must use perspective.

This technique is complex and should be studied carefully before attempting it in a work.

The use of perspective is very common among watercolorists.

Superimposing Planes Through the Atmosphere

Depth can be achieved with a well-defined foreground both in terms of color and form, and a series of successive planes that gradually become more indistinct in the distance. It is essential to bear in mind the farthest planes so as to compensate for the masses in the foreground.

Watercolor is perfect for creating planes of depth by means of atmosphere.

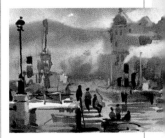

MORE INFORMATION
· Fit and balance **p. 32**
· Superimposing planes in watercolor **p. 68**

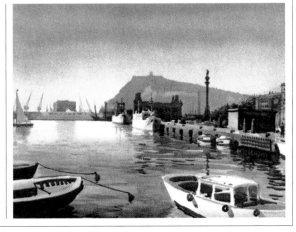

BASIC WATERCOLOR TECHNIQUES

As a pictorial medium, watercolor has a large number of possibilities that painters use according to their own expressive capacity. What is specific to watercolor is basically its capacity to accumulate or disperse paint (reserve or accumulate color in a determined area) for which there are various techniques. Naturally, these techniques have to be experimented with first, if the painter is to expect reasonable results.

Watercolor Applications

After oils, watercolor is the most popular medium among painters. Aside from its lower cost, it is a fact that watercolor has more applications than oils, since it is used in all manner of fields, ranging from design and illustration to its use in the depiction of architectural studies.

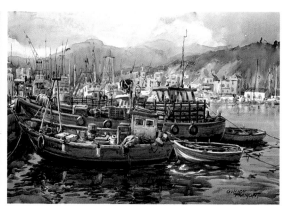

A landscape in watercolor.

Watercolor is firmly established in the field of illustration.

begin with a pale approximation of the final color, and by gradually reducing the amount of water, to obtain the darkest and most opaque tones. How transparent a stain is depends on the quantity of water applied with the paint.

Staining in Watercolor

Since watercolor is a transparent medium, it is not possible to superimpose light colors over dark ones. This fact forces the painter to always begin with light colors that can gradually be darkened during the session.

The transparency of watercolor also allows the artist to

Watercolor is a transparent medium; therefore, you should apply the lighter colors first.

The portrait executed in watercolor offers luminosity and realism.

MORE INFORMATION

· Advanced techniques and effects **p. 38**

Transparency

The transparency of watercolor means you have to paint from more to less, that is to say, the first colors must establish the color base, including white, from which the definitive colors can be obtained by adding tonalities, always remembering to reserve those colors that are to stay bright and light.

In watercolor, it is not possible to position light colors next to dark ones in order to create contrast. The opposite is true: a dark color can always be added, a transparent color cannot.

The transparency of watercolor allows tones to be superimposed, assimilating the second layer with that of the first.

Modifying Tones and Lights

The obvious difficulty of watercolor is the irreversibility of the color, although you can play with its tonal value. It is not possible to go back in search of a lighter tone, but it is possible to darken a tone, reserving those zones that you want to keep light.

Likewise, it is possible to modify colors that may clash with the final chromatic balance by blending them with others. If blue, although dry, is added to yellow, the resulting color will be green, which in turn could equally be modified with other colors.

Colors can be modified with a glaze of another color or tone over that which is dry.

Outstanding Effects

The effects achieved in this remarkable work by John Singer Sargent 1856–1925 are truly astounding. The white reserves have been kept intact from the outset and have gradually acquired strength as the darker colors have been applied next to them. Color synthesis and the stain have been employed to their extreme since no elements in the painting are superfluous.

John Singer Sargent, River in the Mountain

The Art of Watercolor

There are many types of alterations that can be carried out with watercolor. In principle, the most basic techniques consist of working on wet or on dry. Once the technique is chosen, everything else entails manipulating the paint. Match the letters below with those in the painting at the bottom

A. Absorbing damp paint with a clean and dry brush.

B. Using wax for creating spaces in reserve.

C. Carrying out removable reserves with masking fluid.

D. Scratching the paper while it is still wet to open up whites or accumulate paint.

E. Using salt over wet paint in order to obtain textures.

Watercolor techniques.

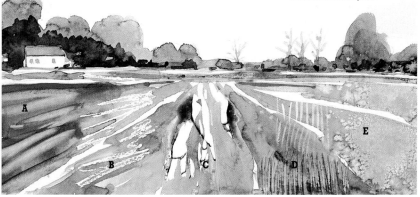

ADVANCED TECHNIQUES AND EFFECTS (1)

The next few pages are designed to show you a number of watercolor techniques and effects. Bear in mind, however, that what is explained here is by no means everything that can be achieved in this medium.

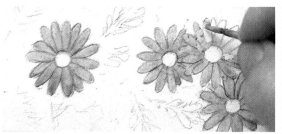

Masking fluid is applied with a brush.

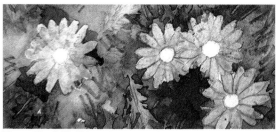

The masking fluid will keep the areas you have reserved sealed while you paint the rest in watercolor.

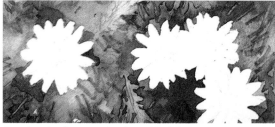

Once the painted areas are dry, the masking fluid can be removed with an eraser.

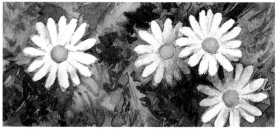

Now the reserved zones can be painted with light colors.

Reserving with Masking Fluid

Masking fluid is applied with a brush in the areas you wish to reserve free from wash or denser colors. Once you have finished the initial drawing, you can apply the masking fluid with a fine synthetic brush. The masking fluid is of a light green or creamy color, so that you can see where it has been applied.

After the areas have been reserved with the fluid, you can paint over and around them without limitations; the fluid rejects the watercolor, and thus continues to remain visible.

Once the paint is dry, the masking fluid can be removed with an eraser, uncovering the white paper. Then the reserved areas can be painted with the colors of the model.

Reserving with White Wax

Wax is a perfect water repellent; therefore, it can be used in those zones that are reserved for highlights or simply for maintaining the white of the paper.

The reserves need not be thick; since the paper is grainy, the pressure applied with the wax crayon will fill in most of the pores.

Unlike masking fluid, white wax, once applied, cannot be removed and keeps the white permanently. Nonetheless, if the layer is very thin, you can scrape it off with a knife.

Scrubbing out Whites in Dry Paint

This method allows you to obtain a white in a dark area that is already dry. With a

The areas to be reserved are painted with a stick of white wax.

The wax repels the water medium.

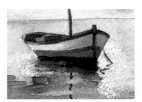

synthetic or bristle brush, wet the area with plenty of water. Let the water sit for a minute or two to soften the paper and the paint, and then run softly with a clean brush until the deposited water begins to get cloudy with the loosened paint. Then dry the area with blotting paper.

In order to open up whites in this area, first you apply a wet brush over the zone several times.

When the area is wet enough, use a clean dry brush to soak up the paint.

Other Opening up Methods

The knife is an excellent accessory for opening up delicate white lines in a watercolor. Care must be taken, however, not to cut the paper itself. Therefore, the knife has to be applied at an angle so that it scrapes rather than cuts; this generally needs to be done several times.

Another technique for opening up whites consists of rubbing the area with a small piece of 3/0 sandpaper. If the paper you are working on is of good quality and thick, the white opened up will be brighter and will allow a perfect repainting.

Frottage or Rubbing with a Brush

The *frottage* technique involves painting with an almost dry brush, which, when rubbed, produces texture. Lack of moisture stops the

Sandpaper can be used over a painted surface.

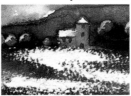

paint from penetrating the grain so that it just stays on top.

In addition to its use for creating contrasting textures, *frottage* is used for erasing contour lines.

Each paper gives different results, so it is important to try out the results before applying it to your picture.

An almost dry brush is rubbed over the surface of the paper in order to obtain this effect.

Once the sandpaper has been applied, it is possible to repaint the zone.

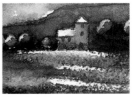

The white lines were opened up by scraping the surface with a bevel edge knife, taking care not to cut the paper.

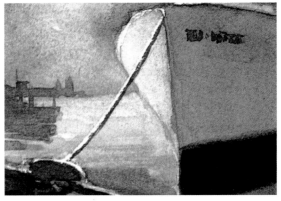

ADVANCED TECHNIQUES AND EFFECTS (2)

A technique cannot be mastered in a couple of days; it requires patience and, above all, practice. Sometimes a fortuitous accident can open the door to new creative methods. At any rate, the painter must be conscious that a technique is a means to an end, not just a visual effect or a trick.

Transfer

Transfer is a technique of pressing a recently painted and still wet paper against another paper. The pressure transfers the wet area, creating a texture. This effect is applicable for backgrounds, walls, ground, hills, etc.

To apply this type of transfer over a watercolor painting, the zones you do not wish to paint must be masked, which is something that can be carried out with masking fluid or with a paper mask placed between the paper with the stain and the painting.

Textural Effects with Water

Very rich textural effects can be achieved merely by loading the brush with clean water and applying it to a re-

Painting with water enables the painter to displace the paint toward the contours, creating interesting effects.

cently painted area that is still damp. This displaces the watercolor pigment outside the water stain, accumulating a large amount of color on the contour. These empty spaces can then be repainted with another tone or color.

Painting with a Toothpick

Using a stick or toothpick loaded with watercolor from a brush, you can paint and draw, define lines, etc. The moist paper dilutes the paint from the toothpick, making it run and creating an original effect.

A dry piece of paper is applied over the recently painted surface.

The result of the pressure produces surprising effects.

A toothpick wetted in watercolor can be applied over a recently painted area to draw lines that expand due to the effect of the water on the paper.

Turpentine can be used over wet watercolors to create interesting effects.

Textural Effects with Turpentine

Turpentine is not compatible with water; it is an oil and, as such, has a different density than water.

If a synthetic brush is loaded with turpentine and brushed over a freshly painted, still damp area, when it comes into contact with the watercolor, light-colored, irregularly-shaped stains are formed, creating special effects and textures.

Given the fact that turpentine and the water of watercolor are incompatible, it is difficult to work over the effects obtained.

Therefore, the painter should experiment continuously with this technique in order to discover new results.

MORE INFORMATION

- Basic watercolor techniques **p. 36**
- Reserving **p. 48**
- Working on wet, working on dry **p. 50**
- Airbrush painting **p. 84**

Texture by Spattering

In the example below some zones are so light that they dull the contrast of the picture´s forms. This calls for a technique called spattering. First cover the area you do not want touched with a paper mask. Then to achieve spattering, a toothbrush loaded with color is dragged across the teeth of an ordinary comb. This dragging produces a spray of liquid watercolor.

Interesting textures somewhat akin to pointillism can be achieved using a toothbrush and a comb.

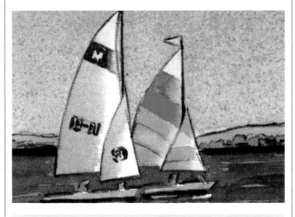

Watercolor and Airbrush Painting

One of the most effective applications of watercolor is its use with the airbrush. It is possible to obtain truly astonishing and hyper-realistic results. The airbrush is employed above all in the

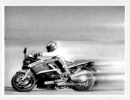

Miquel Ferrón, Motorcyclist.

world of illustration and design, although many artists still use it on their paintings.

THE STILL LIFE: GRADATION AND LIGHT IN SIMPLE ELEMENTS

No matter how simple the motif, the execution of a watercolor can lead to a high degree of complexity. It is essential to carry out a correct study of the model's volume and the characteristics of the surface and texture of the different objects. A study of the light over the different objects gives different results in each one of them according to their surface.

Reviewing the Wash Technique

The only real difference between watercolor and wash is that the former possesses greater chromaticity.

It is a well-known fact that by using only two colors it is possible to obtain a wide range of tones. It all boils down to choosing those colors that embrace a large part of the spectrum of the chromatic range. For instance, if you choose cobalt blue and burnt umber, you will be adding a third color as a result of mixing the two together: black.

To say that a watercolor has been painted with three colors is not entirely true, white also counts as a color, since the transparency of this medium uses the background to determine the brightness of the color chosen.

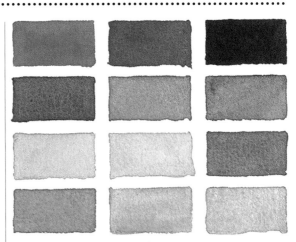

A wide range of tones.

Creating Tonal Variations

With the three colors previously mentioned, it is possible to paint a wide range of tonal variations, either cool or warm, giving as the coolest the color chosen from among the blues and as the warmest, that

You cannot affirm that your watercolor is to be painted using only the three colors shown below, since the white of the paper is as much a color as the others.

chosen from among the earths, in this case burnt umber.

Mixing each of these colores in different proportions with a greater or lesser amount of black produces a wide spectrum; similarly, by adding white you will obtain different lighter versions of the tone in question.

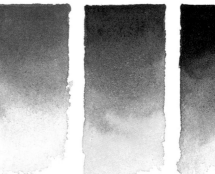

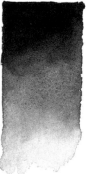

Setting up a Simple Still Life

A still life may contain almost any object, but if you want to paint a study of lights and volumes, it is better to paint simple elements, if possible geometric forms like a cube or a cylinder.

As you can see in the accompanying pattern, they are easy to cut out and put together. Once you have them ready, you should decide on the type of lighting you need; a laterally positioned lamp and a white background will produce soft shadows, enabling you to easily distinguish the tones of the sides of the cube and a soft gradation of shadow in the cylinder.

Drawing and Reserving with Masking Fluid

For this still life, you have to note the plane on which the objects are situated and the relationship of distances between them. Once the drawing is complete, the highlighted areas, in this case the glass, are gone over with masking fluid.

Once the drawing is complete, masking fluid is applied over the elements to be reserved.

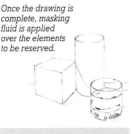

Patterns for constructing the cube and cylinder models.

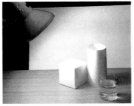

A still life with two elements and a glass of water. Lighting is fundamental.

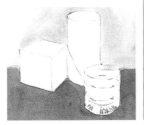

Once the background has been painted, it should be left to dry before starting on the elements.

Synthesis of Volume

The best way to understand volume is to box the forms you are drawing within basic geometric shapes. Such as cubes and cylinders.

Painting the Objects and the Background

First wet the background with a sponge and then outline the objects with a brush; in this way the color you are going to use will not invade the dry reserved areas. Now the background is painted with a warm gray wash. When this layer has dried, the table is painted using a mix of burnt umber and blue.

Once both areas are dry, the visible part of the cylinder is wetted, reserving the area taken up by the glass, and a dark stripe of bluish gray is painted down one side. Without allowing this to dry, take up a clean and dry brush to dilute the color in the shadowy area by gradating it as it moves toward the illuminated zone. Once this is dry, paint the two tones of the cube.

The glass is also painted by zones, a stripe of the color of the table following the volume of the form and, somewhat less defined, the shapes that can be seen behind the glass. When it has dried, the masking fluid is removed using a rubber eraser.

After painting the figures, the masking fluid is removed.

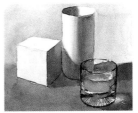

MORE INFORMATION

• Synthesizing forms **p. 24**
• Drawing, the foundation of watercolor. The still life **p. 30**
• Watercolor and wash **p. 22**

STILL LIFE: THE MODEL

Flowers are a particularly common motif in still life work. It is a theme that can be treated in many different ways, but it is essential to make sure that the lighting you are going to use is appropriate for this or, for that matter, any other model for a still life theme.

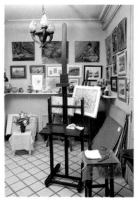

In the studio, the model should be situated so that the painter can study it thoroughly.

Study of the Model

When you decide to create a still life, it is essential to remember that neither the drawing nor the painting can be achieved directly on the first attempt, especially with such a lively medium as watercolor. So it is important to make sketches of what you are going to paint. This does not imply that your color notes have less value than the definitive painting; on the contrary, you will find that many of these spontaneously painted notes possess a high degree of freshness that is difficult to capture in a more elaborated work.

You needn't worry about going into details when executing notes, although the synthesis of form and color should be correct.

Lighting the Model

The sketch must also resolve questions such as lighting and composition, always favoring those aspects that best emphasize the motif of the painting.

For instance, since we know that when the subject is against a darker background its colors will appear brighter and more luminous, we may decide to deliberately darken the background so as to obtain such an effect.

The variation of the background affects the contrast of the model.

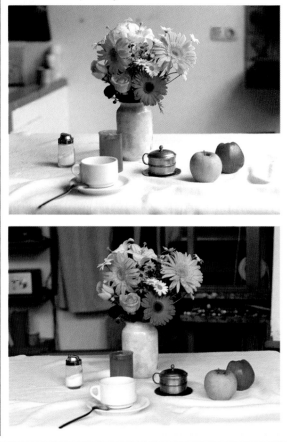

Types of Illumination

There are many variations of lighting, each of which has its own particular advantages:

• Direct light accentuates the contrast among the colors and produces hard shadows.

• Diffuse or overhead lighting, as the name suggests, is directed from a position above the model. This type of light tends to bounce off the objects, softening the contrast both between the colors and the shadows.

The following two types of lighting affect the model in different ways:

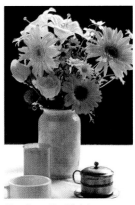

The effect of backlighting.

• Frontal lighting suppresses the shadows and highlights the color; frontal-lateral lighting reveals the volumes and shapes in a more natural way.

• Backlighting, which comes from a spotlight placed behind the subject, softens the forms and colors and gives more importance to the model's contour; if, on the other hand, we situate a reflector screen to one side of the subject, the brighter effect that is achieved envelops the shadows and produces a better definition of the colors.

MORE INFORMATION

• The still life: gradation and light in simple elements **p. 42**

Contrast and Color

Contrast between colors can be achieved in the following ways:

• By means of simultaneous contrast, that is, a color appears darker when the color around it is lighter, and vice-versa, a color appears lighter when the color around it is darker.

• By the juxtaposition of complementary colors. For instance, carmine can produce a juxtaposed contrast by painting its complementary, green, around it.

Juxtaposition of colors consists of placing two complementary colors together.

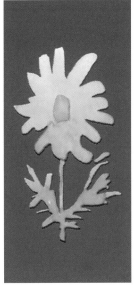

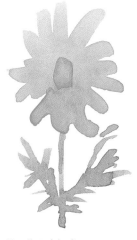

The effect of simultaneous contrast...a color appears lighter when the color around it is darker.

Van Gogh on Sketching

Van Gogh considered the color sketch to be a definitive work. As he very often commented in letters to his brother Theo, "I believe that to paint color notes is to sow, to paint pictures, to harvest." This is the reason why so many of his still lifes painted in watercolor have been preserved in the form of sketches.

Fragment of one of Van Gogh's letters in which he explains his paintings to Theo.

TECHNIQUE AND PRACTICE

BOXING FLOWERS AND THE MODEL'S TEXTURE

If drawing is the foundation of watercolor, it is evident that the representation of such delicate elements as flowers requires a clear, crisp design in order to avoid complications when you begin your painting.

The objects of the model not only differ in form but in their position, a fact that requires the artist to synthesize and understand space and lights.

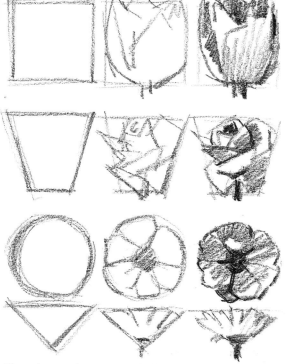

Understanding the Model

Some objects are easier to draw than others. The closer an object is to a geometric shape, the easier it is to draw it.

All objects in nature can be reduced to basic geometric shapes, although with practice you should eventually be able to box them within more complex forms.

When you come to draw a flower, you should never get

Flower shapes can be schematized as geometric forms from which to make a complete drawing.

bogged down in minute details of petals and such. The best advice is to look at the flower through squinted eyes in order to see what geometric shape it most approximates and then try to get it down on paper as quickly and spontaneously as possible.

Volume and Chiaroscuro

Watercolor painting does not require a gray scale, but it is wise to execute several drawings that include the different tonal values. This can be useful as a guide for translating the different gray tones into chromatic tones.

In watercolor, the shadows define the volume of an object and the highlights are produced by the white of the paper.

Once the volumes of the flowers have been boxed, the different dark tones complement the brightest zones.

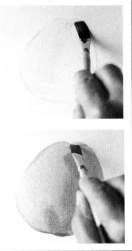

A pencil sketch helps painters to understand the variation of grays.

MORE INFORMATION

- Color theory applied to watercolor **p. 26**
- Reserving **p. 48**
- Glazes in still lifes **p. 52**

Watercolor painting stages of an apple. Light plays an important role where color is applied in order to provide volume.

Volume Through Color

In simple objects such as an apple, the tonal value can be represented by means of color. First sketch only the outline, without indicating any shadow. Then, wet the entire surface of the apple with a wet brush. Now apply a yellow (a somewhat dirty ochre tone) in the lightest part on the right-hand side, and then dry it partially with a blotting paper. Paint several touches of carmine and blue over the still-damp yellow. The result obtained from these two tones is a dark sienna, which enables you to begin to distinguish between the zones of light and those in shadow.

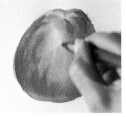

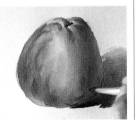

Color and Texture

You now apply several vertical brushstrokes of carmine to accentuate the contrast and bring out the shape of the apple. With the paint still wet, remove part of it from the area that corresponds to the shine with a clean dry brush and, once the paint has dried, try to give it an apple-type texture with some brushstrokes. Then charge in a wet grayish wash for the shadow, brushing most of the wet color toward the darker area of the apple.

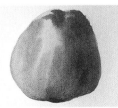

The successive glazes that are superimposed provide a transparent effect.

Volume and Watercolor

Volume is shown by means of a gradual positioning of pale and dark colors according to their proximity to the observer's point of view. In this case, the volume is obtained by taking maximal advantage of the light zones of each object, and barely insinuating color in the darker zones.

The white of the paper remains predominant throughout the whole of the picture.

Charles Reid, Table and Flowers.

RESERVING

The underlying colors play a decisive role when painting with watercolors. Therefore, it is important to always think about reserving those zones that are intended to be painted with lighter colors, since a light color can never be applied over a dark one.

Natural Reserve

The fundamental characteristic of watercolor is the way in which the painter works using the color of the surface, since in watercolor white is provided by the white of the paper. Sometimes, reserving an area may be difficult due to the complexity of the object's shape or because the background it stands out against is light itself.

The easiest method of reserving is to paint the background carefully, making sure

Here, the flower is reserved by painting the darkest zones around the figure, leaving the inside part white.

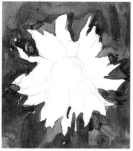

When the background has dried, the inside of the flower can be painted. Since the background is darker, this light color cannot affect it.

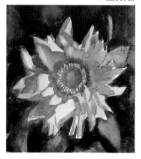

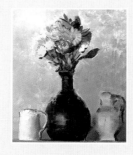

Contrast and Reserving

To paint this still life, Francesc Crespo reserved the area destined for the flowers; then he painted the darkest and least luminous colors, leaving room for the vibrant chromaticism of the bouquet.

that the paint does not overlap into those zones that have been reserved for lighter colors, which you can later paint by using the darker tones of the same range to reinforce the shadows.

Protective Reserves

Another option for reserving whites which are needed where the background is complex or flows behind the object is to use masking fluid.

The whites must be reserved by applying masking fluid over the areas in question. Once it has dried, you can go ahead and paint the background without fear of the paint overlapping into reserved areas. When you have finished and are ready to paint in the reserved zones, the masking fluid must first be removed using a rubber eraser or you can even scratch it off with your fingernail. Once the masking fluid has been entirely removed, the reserved zones will appear perfectly white and shiny and you can complete them by using either the dry or wet techniques.

Masking fluid can be employed as often as you like, provided the background is completely dry and the color reserved is always lighter than that of the background.

Reserving in Practice

Reserving is shown in the two examples on the left.

After a meticulous boxing, the background and the most voluminous forms are painted, leaving until last the smallest and most delicate zones in contact with dark zones. The whites are reserved with masking fluid and the leaves are painted in dark green.

The darkest colors and the background are painted, reserving the white zones.

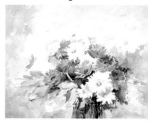

Boxing Flowers and the Model's Texture **49**
Reserving
Working on Wet, Working on Dry

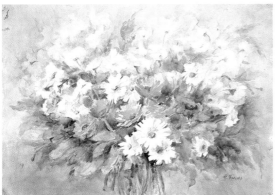

Then the masking fluid is removed and tones of gray are added to the white flowers.

Color Harmony

It is essential to reserve when painting in watercolor in order to be able to work with bright colors that you want to have in the background.

The function of the reserved space is to conserve the darkest stain, but, whether you reserve it with masking fluid or manually, it is the harmonic range that dictates the intona-

Here darks have been added, and white reserves made with masking fluid have been removed with an eraser.

tion of the colors, including the brightest, since the harmonic tendency is more intense.

Warm, Cool, and Neutral Range

The warm range of colors comprises yellows, ochres, reds, carmines; the cool range consists of blues, greens, violets, etc. The neutral range is made up of "grays" or so-called "dirty colors." The choice of one color range does not mean that we cannot include colors from the other ranges, but simply that the predominant color should belong to the chosen range.

Harmonious neutral range.

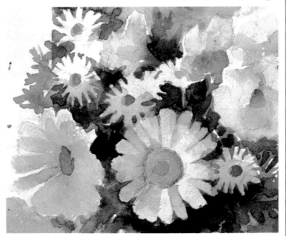

> ### MORE INFORMATION
> • Basic watercolor techniques **p. 36**
> • Advanced techniques and effects **p. 38**
> • Glazes in still lifes **p. 52**

Harmonious cool range.

Harmonious warm range.

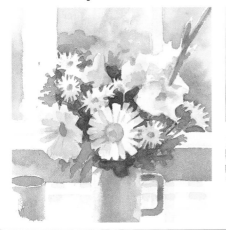

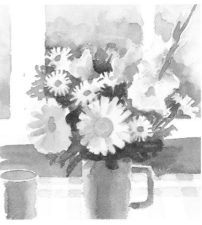

WORKING ON WET, WORKING ON DRY

The capability of watercolor to combine two techniques that offer endless possibilities makes this medium an ideal instrument for painting any theme. In still life, watercolors can be used to outline forms and paint in sharp details, or to produce a more indistinct result, as if it were colored glaze. Working with watercolors on a dry surface prevents the color from spreading, allowing each form to be outlined without the colors mixing into each other.

Sketches for Dry Watercolors

Watercolors can be used in a highly precise and controlled way providing you work on dry, i.e., without wetting the paper beforehand. This does, however, present the painter with certain difficulties as far as corrections are concerned, for once the theme has been painted it is impossible to repaint or retouch it.

Such problems should not dissuade the painter because there are solutions for everything, such as painting an initial sketch to determine the colors and lights. This can be quite a rough sketch, painted quickly without waiting for the colors to dry. If you want to avoid the painted areas mixing into each other, however, you should leave a blank space between one area and another.

A quick sketch will enable you to situate the first colored areas correctly.

First the upper section was wetted, quickly blending the colors. Once it was dry, the remaining flowers were sketched in rapidly and roughly.

Materials for Sketches

Very few materials are needed for making a watercolor sketch; paper, paint, water, and three brushes should be enough. The theme is closely associated with the colors to be used, and although only three colors are used, it is always important to have a wide range of colors available for painting flowers (for example, such as the selection shown below).

Although few colors are used, it is important to have as wide a range as possible available.

A good palette is also necessary for mixing the colors. With certain types of paintboxes, the tray of pans can be removed, leaving a large area for mixing the paints.

Painting on Dry

To paint on dry in watercolor, the initial layers of paint must be totally dry so the colors do not spread. With this technique, it is easy to control the brushstrokes and the way color spreads over the area to be painted although, this does not mean that in certain areas you cannot also work on wet. When painting on dry, each color, or painted area, must be dried before adding new tones (this process can be speeded up by using a hair dryer).

In this way, the painting is developed by entire areas: first the background, then the cup, and so on. By wetting the paper in the area of the tablecloth, wash can be used to suggest the shadows of the objects.

Drying can be speeded up using a hair dryer.

A new glaze can be applied on the dry surface without the colors mixing together.

Entire areas of the painting are finished, first the background and then the objects on the table.

By wetting the area of the paper where the tablecloth is to be painted, the artist can use wash for the shadows cast by the objects.

Final Touches to Flowers Painted on Dry

When the background is completely dry, you can then paint the areas you reserved earlier and the remaining objects in the still life.

Painting the darker areas; the area for the flowers is reserved.

Dürer and Flowers

Dürer painted the first watercolors in the western world, and his manner of applying this technique is still used today. These flowers were painted alternating the wet and dry techniques, measuring the drying times, and blending the color in the shaded areas. The result is of the same quality as some of the best oil paintings.

Albrecht Dürer, Iris.

The flowers are painted in two stages: one on wet to blend the colors and another on dry to add more defined brushwork without the tones and colors blending together.

On a dry background, the flowers are painted after wetting this area so that they will blend into each other.

The Wet-Dry Approach

A watercolor may be the result of a combination of techniques, but if you alternate the wet and dry techniques, the painting produced is the same as that seen by the human eye, i.e. by creating planes of depth, because paint applied on wet tends to spread and can merge with the background, while painting on dry is used for sharply defining the planes in the foreground. A possible composition would then be to paint on wet the flowers that are farther away from the observer and the closer ones on dry.

The wet approach was used with the flowers in the background; those in the foreground have benefitted from the reserve-mediated dry approach.

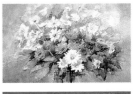

MORE INFORMATION
- Basic watercolor techniques **p. 36**
- Advanced techniques and effects **p. 38**
- Reserving **p. 48**

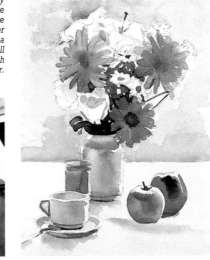

GLAZES IN STILL LIFES

Glazes have been used in watercolors ever since this technique has been in existence. Watercolors, as the name itself suggests, are water based and therefore highly transparent. Glazing allows the artist to superimpose layers of paint in order to create transparency, an essential feature of flowers.

Sketching the Glaze

If you choose to paint more with light than with color itself, the center of interest, the flowers in this case, should be lighter than the rest of the composition. The pencil sketch need not be so elaborate as in painting on dry, as it is the watercolor itself which, via the superimposing of planes, defines the forms that most interest us. In this sketch, more importance has been attached to the flowers in the center than the rest of the composition. The example shows how the white flowers stand out more sharply against a dark background.

Simple scheme that includes only the main volumes of color.

Sketch of the initial staining of the flowers.

The Initial Staining

As watercolors are painted using the transparency of the colors, a picture produced from glazes should start with highly transparent colors, so that fresh, darker colors can be superimposed without the result actually becoming opaque.

This initial sketching includes several light grays that should be left to dry so that the

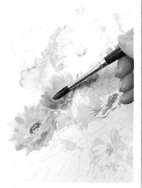

Over this initial staining, a second glaze reinforces the color and increases the warmest intensities.

Once these first flowers have dried, the background is dampened and then stained with brownish colors.

colors do not mix because of the dampness.

It is essential in glaze work that the underlying colors be left to dry, as they should show through the superimposed color.

Glazes and Reserves

All the flowers that have a particular color should be painted using the technique that is proper for opaque colors, directly on the white paper.

Care should be taken to superimpose the colors correctly, matching the previously painted flowers.

Take care, however, that you leave the areas that are to be white or lighter than the others unpainted. For example, a white flower in the foreground is not painted as such, yet suggested by the outline of the surrounding colors.

The background glaze outlines the area reserved for the mass of flowers.

Working on Wet, Working on Dry
Glazes in Still Lifes
Watercolor in Practice: the Landscape

53

You must wait until the previous glaze dries to paint the flowers in the reserved areas.

Highlighting the Foreground

The different planes of a watercolor produced by glazes are evident by how they reinforce the areas closest to the observer. In order to create this effect of proximity and highlight the white flowers and their brilliance, a contrast must be created between the background and the motif by applying grays to the area intended for the background, so that the lighter colors are not invaded by this new color.

Once you have decided where the most luminous areas are to be, they are reinforced by painting the darker areas, i.e., the shadows that the white flowers cast on the vase.

The darker tones in the foreground reinforce the blank spaces formed by the white flowers.

Dark greens are used on wet to represent leaves that blend into the background.

Glaze, a Slow Technique

Glaze work is slow and requires a great deal of patience; yet it is the only way of achieving such surprising effects as those shown in this still life, in which each of the layers has been left to dry, ready for subsequent colors.

Different layers of glaze have been alternated. These are fine, transparent layers of color, some painted on wet and some on dry.

Superimposed Color

Glazes are formed by superimposing colors once the underlying color has dried completely. Then, having fully resolved the construction of the flowers, fine and transparent layers of color are added, enriching the earlier ones and again leaving certain areas untouched, such as the stalks of several flowers and even the outline of the leaves that were not intended to appear originally, but which the composition now calls for.

The new colors increase the intensity of some of the original ones, while they hold in check the luminosity of others.

MORE INFORMATION
• Basic watercolor techniques **p. 36**
• Advanced techniques and effects **p. 38**
• Reserving **p. 48**
• Working on wet, working on dry **p. 50**

DEVELOPING A WATERCOLOR IN PRACTICE: THE LANDSCAPE

Landscape painting is similar to still life painting in that there should exist a certain coherence between the objects represented, without their being too cluttered together nor too spread out. Watercolor is a rapid medium, and so a landscape requires spontaneous, but at the same time complex and diversified techniques to achieve its artistic potential. Everything, however, depends on the initial planning of the picture, i.e., the framing, composition, and initial staining.

The Model

When painting a landscape, you must choose one of the several different styles this genre offers: the rural or urban landscape or the seascape.

The model you choose need not be a real landscape. A photograph may be used or even a prior sketch you may have made. Yet it is always advisable to enlarge your experience by working outside the studio, to capture the real light, climate, and atmosphere.

Boxing the Model

If you look closely at the model, you will see that, among the different possible ways of framing it, there is always one that provides the best distribution of the masses of color over the surface of the painting. The process of framing the model will also depend on the effect you wish to achieve. A loose drawing, with undefined forms will produce a painting that is equally loose and with undefined boundaries. If, on the other hand, the forms are drawn concisely, the subsequent painting stage will be more specific and detailed,

Framing the forms using waxes.

leading to a more finished work.

The prior sketch is just as important as the medium with which it is produced. A pencil sketch may be invisible in the finished work. If, however, a wax stick is used, and depending on how firmly it was applied, it will produce lines that will persist throughout all the painting stages.

Staining by Area and Tone

Watercolor is an extremely delicate medium in which er-

rors are very difficult to rectify, and so requires a systematic, rigorous application on the part of the watercolorist.

You should always start with light colors. This will form a contrast with the subsequent, darker colors, because their transparency makes them easy to darken, yet very difficult to lighten.

Thus, the initial staining should always be lighter than the subsequent colors. If a violet color is used, the later tonalities of this color should always be darker than the original hue.

The overall staining has established the color base on which subsequent masses of color will be built. Each unfinished area represents the starting tones, and colors that will show through subsequent layers.

MORE INFORMATION
· Framing and synthesis **p. 56**
· Superimposing planes in watercolor **p. 68**
· Synthesizing landscapes in watercolor **p. 76**

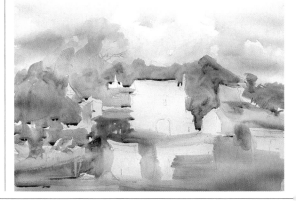

Superimposing Dark Tones

Once the light-colored base is totally dry, it will act as a guide for the stains that are to define the forms; these stains,

The darkest tonalities are used to define the forms against the background color.

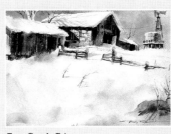

Tony Couch, **Crisp.**

The Importance of Reserved Areas

The construction of a landscape is closely linked to the structure of the forms that go to make it up. Occasionally, the forms left unpainted are those that are most important in the composition, as is the case with this work done by Tony Couch, where there are few elements that have been actually painted, as most of the painting is composed of the white areas of the roofs and the snowy surroundings.

tree, the areas for the branches should be left unpainted so that the shape you obtain has the color of the background.

Glazes and Drying

The tone of the painting should gradually increase via an analysis of the lights produced by the model and allowing the painted areas that are not to be modified to dry completely so that they do not bleed. Thus, when you want to intensify the tone of certain areas, you only need apply a transparent glaze of the dominant color on the dry base.

Above all, the glaze should be highly transparent and not dilute the underlying color, so little water should be used.

Glazes are superimposed to create a dominant tone, again allowing blank spaces to be left for the brighter areas of the volumes created.

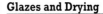

Each of the painted areas of the canvas has a blank space that becomes the most brilliant and luminous point within the volume they represent.

although darker than the underlying color, are still transparent. Superimposing tones not only creates volume but also establishes planes that are situated within the context of the painting.

Any new colors you add must not encroach upon the areas you wish to remain visible; for example, when painting a

FRAMING AND SYNTHESIS

One of the main virtues an artist may possess is the ability to synthesize. This means being able to summarize something, although it is ironic that the simplest things are occasionally the hardest to put in the picture. Painting through synthesis is not an easy task; it requires selecting and eliminating objects plus a profound knowledge of the space surrounding the subject and also that allotted on the paper for the painting itself.

Once the motif has been framed, the forms can be synthesized by squinting slightly at the scene, as different areas are then seen as single masses of color.

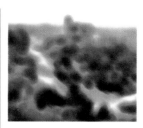

The main lines of perspective can be defined as the main lines of interest of the motif.

Framing the Model

Framing a landscape is simply selecting which part of it to represent.

Watercolor has great artistic potential, though this does not mean it is a specific medium for painting large open spaces. Within a given frame you can pick out specific items. Just get as close as you wish to the model to achieve the desired proportions.

You can select the view you wish to paint by simply looking at the model, although a cardboard viewfinder can be useful to locate a site that is in proportion to the format of the paper you are using.

Synthesis and Perspective

Eliminating unnecessary detail is an integral part of watercolor painting.

When observing a landscape, one must be able to see the lines of demarcation, even though it may appear difficult. Often these difficulties arise from an incomplete knowledge of technical subjects such as perspective.

Perspective in landscapes, especially in the framing that reveals depth without separating planes, is a prerequisite for capturing the landscape with just the right number of lines.

The main lines run from the viewpoint of the observer until they converge at the vanishing point, and objects are naturally reduced in size the farther away they are situated.

There are precise means of establishing this reduction in size, though in watercolors it is sufficient to be good at establishing proportions.

The farther away an object is, the greater it is synthesized or summarized.

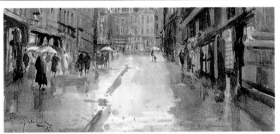

In watercolors, forms can be synthesized by using colored stains and gradations of color. In this case, only the closest cobblestones are suggested; the chromatic unity creates the cobbled effect for the rest of the street.

Synthesis and Form

The form of the objects as they appear in the painting is not necessarily the one they really have. The objects and the textures that appear on the paper have undergone a process of synthesis, of reduction of their three-dimensional shape to the flat surface of the paper.

It is not necessary to copy objects from nature exactly as we see them, For example, a cobbled street on a rainy day can be synthesized using small stains and reflections, without actually painting each and every cobblestone that you see.

Summarizing Color

In the same way that different objects and textures are reduced during synthesis, this is also the case with colors. This does not mean doing away with a varied palette of colors, but knowing when not to use certain colors.

Color is synthesized by reducing it to its original tone and value.

For an economical use of color, highlight the values of the different masses of color. If you wish to paint a field full of flowers, it is obviously unnecessary to paint the different hues of each individual flower; just its abstract color. For ex-

ample, a red dot is enough to paint a poppy, and if it is a bed of flowers in the distance, this color can be synthesized by using a glaze if the background is light colored, or the same area left blank if the background is dark.

Synthesis and Fauvism

The *Wild Ones* as the Fauvists were called, made aggressive use of color. Nevertheless, the chromatic synthesis with which Gauguin painted this work, *Tahitian Landscape,* reaches almost mathematical extremes. It is so carefully balanced that no element is superfluous, as they are represented not separately by masses of color.

Paul Gauguin,
Tahitian Landscape.

Synthesis in the superimposition of planes. The unity of the forms makes them recognizable despite their simplicity and minimalist representation.

LANDSCAPES AND WATERCOLOR
ALLA PRIMA

Watercolor is one of the techniques most preferred by landscape artists. One reason is its simplicity, speed, and spontaneity. This medium truly reflects the creativity of the artist because, being transparent, it hides nothing and reveals how the artist works.

Materials for Painting Notes

For taking quick notes, watercolor paints are ideal. As only water is required, these fresh colors can be used at a moment's notice. Also, large formats are unnecessary for making notes and these can be painted in a pocket-sized sketch pad. Palette boxes containing eight colors are manufactured that fit in your pocket as if they were wallets.

The luminosity of watercolors makes them irreplaceable

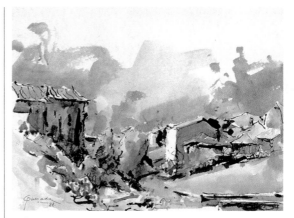

The basic materials for painting notes should be as complete and as light as possible.

for painting quick landscapes. Practice is necessary, however, before an artist can master this technique.

Quick Sketches

The main requirement for making quick sketches is the

Materials and mediums that can be alternated with watercolors for making sketches.

ability to synthesize. This is an ability that is only acquired through practice, but a good piece of advice is to discard everything that is not entirely necessary for the painting, be it form or color. After the model has been chosen, a quick sketch can be made in pencil.

In order to paint a landscape, you must first consider the main areas of color and the areas to leave in reserve without too much concern for chromatic detail, simplifying to as great an extent as possible to capture only those elements that are of interest. If it is the sky, concentrate on that. If it is the framing, make a general color note and nothing else. There will be time to elaborate upon it later on.

The sketch should be a synthesis of both form and color.

Materials should be quick and easy to set up.

Limited Chromaticism

Sketching does not require a wide range of colors; two colors, one warm and one cool are more than enough.

The individual colors, mixtures of these plus the white of the paper provide a wide and full range of tones for quick painting. The basic scheme for the sketch can be done quickly and simply in pencil. Then a light gray mixture is used for painting the sky, reserving the areas for the clouds. Using a cooler color and a wide brush, the area of the water is painted. The brush is then dried and using a little color the ground is added, always leaving unpainted the areas that

The sky is painted using a grayish wash.

Only two colors are used to represent the theme.

Lorain's Quick Sketches

The *View of the River Tiber* is a clear example of a quick sketch. It is, in fact, a highly abstracted wash. Works such as these are valuable material for developing more complex paintings. Sketches provide a quick view of the landscape and its tonal values.

A Subject Framed in Different Ways

One of the main purposes of sketches is to capture the values of the landscape that are to be developed later on. As a result, the more sketches you make of a theme, emphasizing one or several aspects of it, the greater your depth of understanding and familiarity with its different facets will be.

A landscape can be framed in as many ways as you like. A quick sketch shows you how the landscape will appear using a certain frame. This can then be used to paint the landscape in the desired format.

are to be the most luminous.

To finish off, a green wash is applied onto the previous, dry layer, to paint the mountains. This wash is then lightened to paint the ground.

Leaving unpainted the most luminous areas, a very light, gray wash highlights the volumes.

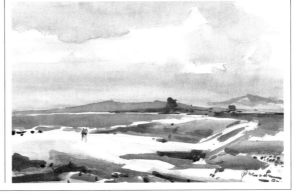

MORE INFORMATION

• Color theory applied to watercolor **p. 26**
• Basic watercolor techniques **p. 36**
• Advanced techniques and effects **p. 38**

INTERPRETING A LANDSCAPE IN WATERCOLOR

There are as many ways to interpret a landscape as there are artists. Once the framing has been decided, a dialogue between the model and the artist begins. It is from this moment that the artist understands the landscape in a certain way.
Depending on the form of interpretation used and the degree of synthesis employed for the landscape, many ideas can be suggested using few elements.

Notions of Interpretation

In order to interpret, first it is necessary to understand; a model is something from which the artist chooses the aspects necessary for the painting and disregards the rest.

The interpretation of a landscape should not be based on a literal copy of it, because what the artist brings to the subject is what is really of importance. An artist sees a landscape, chooses a certain layout, and transfers the landscape to the paper via the color and shapes. That is what interpretation is. And a good interpretation is one that reveals the painter, and the painter's vision, through painting itself.

An overall interpretation of a landscape requires an open approach, focusing on the general forms and disregarding details, so that the landscape is seen as a set of shapes and volumes on different planes.

Careful, Detailed Work

Painting a landscape in watercolor requires a great deal of care and analysis so that the forms maintain cohesion. In this case, everything depends on the artist's ability to add only the most necessary details. Suggesting a form is often so much more effective than minutely drawing it! A landscape can be approached as you see here. Its great complexity lies in its very simplicity. It is a wash with certain features outlined to provide detail and clarity. It is in the foreground where the forms are most defined. This work has used the wet-on-wet technique, blending the background and creating the misty atmosphere. In the nearer foreground the artist has

A landscape can be planned using a detail as the main center of interest. For example, in this watercolor, the representation of the grass and the different shades is the main element, as are the planes in the foreground and middleground.

The washes applied to the background are virtually transparent, creating a sensation of atmosphere in contrast with the foreground.

The interpretation of a landscape should stress openness. More often than not, overall forms rather than details are to be considered, so the landscape is understood as a balanced combination of volumes.

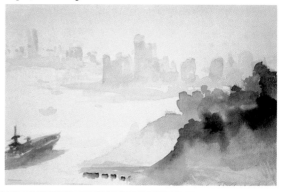

increased the contrasts and used drybrush for completing the final piece.

Abstract Interpretation

Everything we see is susceptible to being interpreted in a more or less abstract way. Abstraction is the ability to single out the essence of things, to understand that a tree can be represented by a dash of color on the paper.

Planning a landscape from an abstract point of view can involve several approaches, from figurative abstraction to pure abstraction. With the former, having a real model as the reference point, an abstraction must be based on the figuration, so that each element

None of the individual forms in this wash could be understood in isolation, but do take on meaning within the whole.

painted in the work refers to an existing element in the model. In this kind of painting the stains are fairly free, although they do correspond to real forms. The use of scale, however, is often less strict than in more naturalist painting.

The Color Process in Landscapes

A landscape can also be interpreted by way of color, as the Impressionist painters often did.

This too is an abstraction of the motif. It aims to convey shapes not strictly from a color concept in which shadows are the absence of light on the object itself, but rather by seeing shadow as chromatic variations independent of the object that casts them.

Color theory comes into play in this style of painting. Colors acquire more importance than the objects themselves. All the colors in a picture are closely interrelated by contrast (greens and reds) and by supplements (tonal variations of a same hue).

Color theory can always be applied to watercolor, remembering that the colors should always be applied from light to dark. In this landscape, a green glaze was applied first and, once dry, blue was added. Finally, the artist added ochre and reds.

Abstraction and the Impressionists

There are some six hundred watercolors by Cézanne that reveal an obvious process of evolution in which the landscape has been interpreted in different ways over time. At the beginning, the forms were clearly defined, yet as his work matured, and despite having the same landscapes as models, they were interpreted almost in a Cubist fashion, as was later developed by Picasso.

*Paul Cézanne
Landscape in Provence.*

MORE INFORMATION
· Chromaticism and depth **p. 64**
· Elements of the landscape. Solutions **p. 72**
· Synthesizing landscapes in watercolors **p. 76**

SKIES AND CLOUDS

Watercolor is the perfect medium for painting landscapes in all their variations, from the most arid landscape to woody scenes, seascapes or urban landscapes. But if there is one feature for which watercolor is unrivaled, it is in painting skies.
The watery nature of this medium allows the artist to create space and atmosphere, thick fog, and skies full of clouds. It was not without reason that Turner used watercolor as the medium for depicting scenes from nature that were highly atmospheric.

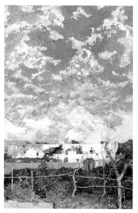

Mariá Fortuny managed to capture all the luminosity of the sky, visible through the clouds, in this watercolor.

Types of Sky in Watercolor

A good watercolorist does not have to avoid painting a certain kind of sky, even if some types of sky are easier to paint than others. Of course, painting a plain, empty sky is hardly complicated; it just requires a wash and lightening of the color on the horizon. Other skies only need certain areas of wash to be absorbed with the dry brush to produce the impression of small, hazy clouds.

It is not always so easy, however, to paint skies. Large clouds and storms require careful study, both of tonal values and composition. However, once these elements are mastered, the results constitute a rewarding experience for the artist.

Sketches of Clouds

It is always a good idea to make pencil sketches of what you intend to paint, and when painting skies and clouds this becomes a most important task. The coloring and compo-

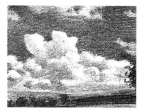

A pencil sketch of the clouds helps you to understand the basic shapes.

sition of clouds should receive the same attention as the rest of the landscape; in fact, on many occasions a landscape is really a framed sky.

The pencil sketch should be made quickly, as clouds change shape almost without our noticing. Once shapes have been sketched in, the darker areas are reinforced

and the gradation of grays of each area of the clouds is done. Lastly, the brightest whites are brought out with the aid of an eraser.

Study of a Sky in Watercolor

Once you have closely studied the model and even made a pencil sketch, you can start on a landscape in which the clouds are the major element. As always, when working with watercolors, it is important that the drawing be fully resolved so that no errors are made with the painting itself. To begin,

The pencil sketch helps to establish the basic forms.

With the upper area damp, the darker zones are painted, leaving the reserves of white.

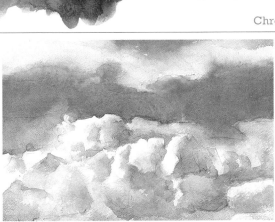

A gray wash is used to paint the darker areas, leaving the white areas in reserve.

damp the upper part of the paper and apply a wash, letting the gradations blend with the white of the paper.

A different gray is used for painting the shadows of the clouds on dry, adding certain warm tones to the mixture. The most highly contrasted areas are intensified by using darker colors.

The Chromatic Range of Clouds

Chromatic harmony exists as such in nature. A certain chromatic range can be decisive for the sky you are painting. A blurred color, such as light ochre can be used to begin, applying it evenly, and once it is dry, the same color is then applied but with the addi-

tion of a little sienna, working in a few gradations in what are intended to be the lighter zones of the clouds.

Also, by applying the theory of simultaneous contrasts, the color of the sky can be painted with ultramarine blue, crimson, and ochre, clarifying the area over the horizon. Lastly, a final wash can be applied to the lower part of the clouds.

MORE INFORMATION

- Perspective in an urban landscape **p. 66**
- Synthesizing landscapes in watercolor **p. 76**
- The seascape. Highlights and contrasts **p. 80**

A sequence of very watery glazes lends unity to the shapes in the sky.

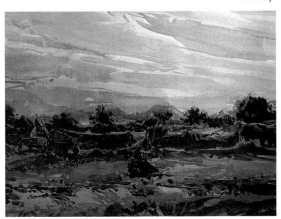

John Constable, a Meticulous Painter

Constable (1776–1837) painted a good number of cloud studies, but he did not do so lightly. His work is so meticulous that on the back of every watercolor he noted down the time and the weather on the day he painted. On the back of this one, for example, it reads, *Study of clouds in a broad landscape, between 11 and 12 am., 15th September, 1830, westerly wind.*

Applying Techniques

The techniques you learn should be used as tools to produce the painting. The technique of gradations on wet can be used to paint interesting skies in which the depth has been re-created, lending greater contrast and opacity to the nearest clouds, while those in the background are gradated and fade away.

Using absorbent paper to remove color and blend the outlines is very important in these cases.

The gentle contrast between the clouds has been achieved by removing some of the color with absorbent paper.

CHROMATICISM AND DEPTH

In landscape painting, one of the most common ways of creating a sensation of depth is through the use of color. When applying color bear in mind that the watercolor technique is based on its transparency, so the sum of two superimposed colors can produce a color that is totally different from either of them. In addition, the colors in a landscape are gradated and undergo chromatic variation as they retreat into the distance.

Planes and Color

The colors in a landscape undergo a chromatic change in the eye of the observer, depending on his distance from the object. This is caused by the atmosphere acting like a filter, so the farther away an object is, the thicker the filter and the greater the change in color.

The watercolor technique allows for progressive gradations of color that can then be gradually blended with others to produce important chromatic changes.

When creating planes of depth, i.e., the superimposing of different elements to establish the distances, these chromatic changes can be carried out individually for each plane, letting each one dry before adding the next so that the colors do not mix.

Depth Created by Different Planes

The sensation of depth can be created in a painting by simultaneously superimposing planes according to their proximity to the observer.

The closest objects naturally will be depicted as larger than those in more distant planes; this way the planes will overlap, both in importance and in size.

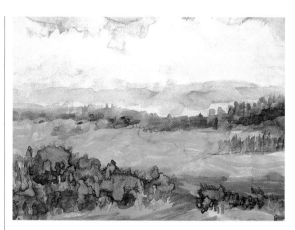

The planes closest to the observer reveal more variety, detail, and contrast than the more distant ones.

A landscape can be planned so that the masses of color indicate the different depths within the painting; in this way, the frontal colors will be more vivid and the contrast with distant planes more striking.

Superimposing Planes and Detail

As the planes recede into the distance, detail progressively fades away. This does not mean you should paint a landscape with an excessive amount of detail in the foreground. Detail can be conveyed during the process of synthesizing colors and shapes.

For example, if a landscape comprises three clearly distinct planes, the detail in the foreground may be simply an accumulation of contrasts, while in the second, the planes are grouped together by tones, rather than contrasts. The farthest plane may be almost monochrome, with color only in those areas that require it.

Contrast in the foreground becomes a tonal modification in the farther planes.

MORE INFORMATION
- Skies and clouds **p. 62**
- Superimposing planes in watercolor **p. 68**

Planes and Composition

The composition of a landscape owes a lot to the situation of the different planes, so the lines that form the landscape indicate the geometrical forms of the different elements present. Depending on how the planes of the painting are situated, the composition will change.

The transparency of watercolors can be used as an aid for the composition of the painting, keeping to the geometrical scheme so the transparency forms part of the colors that decide the harmonic arrangement of the elements.

Separating Planes

The chromatic arrangement also suggests the different planes.

The chromatic range of any landscape always tends toward warmer colors in the foreground and, as the planes recede into the distance, the color gradually becomes cooler, until it is almost a bluish white.

This depends, obviously, on weather conditions, because in many landscapes, above all at dawn or at dusk, there is an increase in warm tones along the horizon line, a result of the sunlight thorough the atmosphere.

Planes and Reserving

White is not used as such in watercolor, and its transparency cannot be applied over a darker one. This requires always leaving certain areas unpainted so that they will appear more luminous despite subsequent layers of paint.

You should decide from the beginning which is to be the lightest color, and from there on add darker tonalities. This process may seem complicated, yet it becomes intuitive through practice.

The spherical nature of the Earth means that the atmosphere is more dense the farther away the object is from the observer, as can be seen in this illustration.

This landscape has been painted with the above idea in mind. The distant objects not only grow smaller, but the atmospheric layer increases and the planes overlap.

Atmosphere and Chromaticism

The spherical nature of the Earth causes an increase in the depth of the different planes. Distant features, such as mountains in the distance, appear smaller in comparison to the closer planes.

The different planes of the painting alternate so that the background color is modified by the superimposition of different glazes.

Depth and Atmosphere

In this watercolor painting by John Varley (1778–1842), the planes are clearly defined both by tonality and by color.

In the area nearest the observer (the left of the painting) the shadows are represented with great detail which tends to fade as the planes recede, until we reach the most distant plane where the buildings appear to blend into the background.

John Varley, York.

Color scheme of the location of the different colors according to their distance from the observer's viewpoint.

PERSPECTIVE IN AN URBAN LANDSCAPE

Creating the third dimension on paper is not only achieved by superimposing planes. The perspective of the objects within the landscape plays an important part to achieve the illusion of depth. Watercolor allows very few corrections to be made, so you must be well aware of the structure of the lines of perspective and develop the painting from there.

Lines of Perspective

Contrary to appearance, it is not difficult to draw in perspective. Nevertheless you must follow certain rules. Perspective can be reduced to the position of vanishing points and the lines that lead toward them from the viewpoint of the observer.

Two straight, parallel lines, like the lines of a railway track,

Basic scheme for representing two objects in perspective. The vanishing lines stretch away to the vanishing point, which is situated on the horizon line.

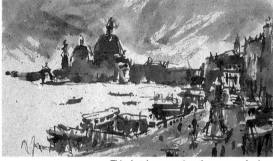

This sketch summarizes the masses of colors, the volumes, and the perspective.

Three-dimensional scheme of the transfer of perspective to the painting.

appear to converge at a single point. Even if the lines were wide apart the final effect is the same. So the perspective of a landscape can be achieved by reducing the compositional elements to lines that tend to converge in the distance.

Watercolor and Perspective

Once you have decided the basic scheme of the painting, the pencil sketch is softened so that it does not interfere with the wash.

For resolving architectural elements such as houses and

other buildings, it is important to work with reserved areas or wait for the base to be dry so that the colors do not mix together.

Above all, always start with light colors or wash, as the most luminous color is the first to be applied and will be concealed later by the subsequent, darker layers.

The use of perspective alternates with the use of reserves, so that each area of the painting remains intact.

Color Synthesis

The architectural elements of the painting are represented not only by the drawing; color is very important for representing their presence and their surroundings. Sometimes, if the drawing cannot adequately explain an element of the painting, color is used for this purpose. The play of light and shadows produces the same effect as vanishing lines, because any object represented in three dimensions always has one side darker than the others. This is a delicate task, as you must start with a light color that will be gradually darkened with delicate nuances in the areas in shadow, until you obtain the desired tone.

The color fades as it recedes from the observer.

The Absence of White

This masterly painting by John Sell Cotman (1782–1842) shows us St. Paul's Cathedral. It alternates perspective created by overlapping planes and a gradation of the background color until it almost disappears. Although watercolor does not use white, the blending of the color with the paper creates this effect.

Urban Landscape, Perspective, and Monochrome

Watercolor painting is especially suited to situations that require atmosphere and depth. Any city or town offers endless pictorial possibilities that may escape the observer who is overly familiar with the scene. From the pictorial point of view, everything changes: a certain perspective can be highlighted or importance lent to subtle elements such as mist, smoke, or steam.

Atmospheric Effects

Creating an atmospheric effect depends entirely on the background you have chosen for the painting. An initial wash will decide the tonality of the atmosphere. It is advisable to go over, on wet, the areas where the glaze should be lightest and most luminous, removing paint with the dry brush or with blotting paper. When it is practically dry, add the lighter tones, using very little color or just the stained (from cleaning your brush). Alternating wet-on-wet and wet-on-dry, tonality increases in the middle and foregrounds, heightening contrast, in the areas with less mist or smoke.

Edward Seago, Light at Dusk. *With minimum variation by hue, he has synthesized color in such a way that the painting becomes almost monochromatic.*

Robert Cozens, The Ruins at Paestum. *A wonderful atmospheric effect created by the contrast of lights and the glazes that lend unity to the background.*

Trevor Chamberlain, Near Wapping. *The effect of depth has been created by the atmosphere and overlapping of different planes.*

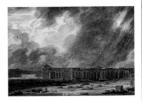

SUPERIMPOSING PLANES IN WATERCOLOR

Being aware of the artistic and technical potential of watercolor is the first step to mastering this medium. At first, it appears that very few colors and elements are used in the painting; but as you learn about this medium, the process of synthesis simplifies the distribution of the elements and the color.
Working with superimposed planes is one of the best ways to master this process of synthesis, as it helps to understand and calculate the tonal values of the different positions of the planes in the model

After observing the model, you can outline the overall structure; the sketch should lay out the different planes and the distances between them.

Establishing Distance

A model has many points of reference that can be used to represent scales and distances on the paper.

Once the points that form the basis of the painting have been situated, i.e., the main reference points of the model, the different distances between the elements of the model require reinforcing.

Planes of Reference

The observer, from his or her viewpoint, sees the different objects of the landscape grouped along the same distance line.

These lines are the *planes of the picture.* Each plane occupies a different distance line and the objects within these planes are interrelated and scaled to each other, not to those on nearer or farther planes.

Scheme of the planes of reference in this work by Joachim Patinir, Landscape with Saint Jerome.

The closer the planes to the viewpoint of the observer, the greater the individuality and the warmer the chromaticism.

The Difference Between Planes

From the viewpoint of the observer, the different planes recede to the horizon line. The number of lines used can vary depending on the degree of depth desired. Planes vary both in proportion and in color. The elements in the foreground are warm tones, and as they retreat into the more distant planes, they lose their individuality and become compact masses of color fused with similar elements. Color loses its brightness in the more distant planes.

The most distant planes are composed of compact masses of color; in the background, blue, followed by a dark green that stands in front of the previous plane.

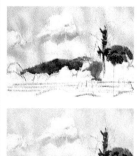

Alternating Planes

It is sometimes difficult to establish clearly the difference between planes in real life, yet this must be done in the painting, inventing different layers of planes.

These planes, naturally, recede away from the observer toward the horizon; so, in a landscape there comes a moment when the most distant planes are concealed by the earlier ones, while only the last plane is visible, in the form of high ground such as, mountains or embankments.

Planes alternate as they do in stage scenery, where a more distant plane can be seen where a closer plane ends.

Planes alternate, appearing superimposed through the color and the definition of the forms.

Planes and Distance

Interpreting distance through planes can be seen clearly in this work by Ives Brayer. This landscape has been resolved using three planes clearly differentiated by the central plane that has been darkened to separate near from far. In addition, the details and the color of the foreground change in the more distant planes, with a reduction of the chromatic range and a greater synthesis of form.

Ives Brayer, Half Light at Baux-de-Provence.

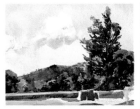

Color and Distance

Distance has a clear effect on tone and color. Sometimes part of the brightness is lost, whereas in other times the color fades until it blends into the background.

Different planes have markedly different tones. Watercolors require you to take their transparency into account and therefore to begin with the lightest colors. This means coloring the farthest planes and then overlaying the others until you reach the foreground.

This procedure is repeated as many times as necessary until the sequence is completed.

The advantage of watercolor is that the tones can be darkened as required, so if a plane has turned out darker than you wanted, you only need increase the tonal intensity of the preceding planes.

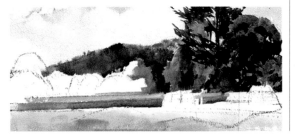

The different planes in the painting evolve in a consistent fashion: a foreground with a variety of tones and forms, a middle ground with defined trees, and lastly the mountains that appear blue in the distance.

Recognizable objects appearing in the closer planes help the observer to relate scales and distance between the other planes within the painting.

MORE INFORMATION
· Perspective in an urban landscape **p. 66**
· Synthesizing landscapes in watercolor **p. 76**

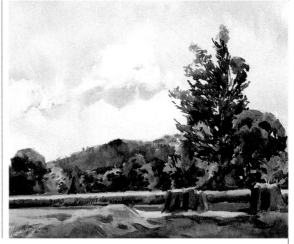

A LANDSCAPE IN WASH

We saw earlier that wash is a preparatory technique for watercolors and yet for many artists wash is their usual medium, not just for quick paintings or sketches, but also for creating complex themes in which monochrome helps to underline the forms.
A landscape painted in wash is doubly valuable: the synthesis, or reduction to a minimum of tones and forms, and its plastic potential for questions such as composition, tonal masses, and everything related with light.

Tonal Values

Wash in watercolor is based on the tonal variations of one or two colors. The different possibilities of watercolor work can be practiced with a short exercise for which you only need a brush, water, one watercolor, and paper.

Take up as much water as possible with the brush and squeeze it out onto the palette. Then lightly take up some of the watercolor and mix it into the water on the palette. The water should be just slightly tinged and can be used to begin with an almost transparent color.

This is then used to paint the entire surface of the paper, which is left to dry.

Then this operation is repeated, except for the upper part of the paper.

When dry, you will see that the sum of the two tonal layers is slightly darker than the first, upper layer. This is the basis of wash.

This wash covers a wide range of tonal values, i.e., grays, and can be used to produce the entire spectrum using a single color where each tone represents a different color of the model.

Planning the Painting

Once you have decided on the model, you prepare the first, highly transparent wash. The amount of color used in this wash should be so little as to be virtually invisible against the white of the paper. Use clean water—the slightest trace of color will stand out against the paper.

This first wash is used for the sky, leaving certain areas in reserve for the clouds. This wash is also used to paint the forms and the volumes in the entire work, leaving the detail for later. The entire procedure should be completed before any part of it dries out, as this would produce a change of tone.

Sky stained with brightest portions reserved.

In this example, the tone blended into the background as it was painted wet-on-wet.

In this case, the dark tone has been painted on dry, increasing the contrast and providing the artist with greater control over the forms.

Increasing the Intensity

When the first wash is dry, you have to decide which will be the darker areas. You can begin by painting the background plane, using the same almost transparent wash you started with. This time the areas left in reserve are the most distant planes, which fuse into the sky, while the closer planes are achieved with equally broad stains, again leaving in reserve those areas that are to be the lightest in the finished painting. When it is dry, you will see how the difference between the forms painted in the background and those in the closer planes has varied substantially. These "staggered" planes should not change tone too sharply, as this would change the distance existing between each plane.

The tones should be carefully graded. The horizon line has been painted in the same tone as before to reinforce it.

The Darker Tones

The painting now contains the different scales of gray, an almost transparent background, and an increase of the intensities by planes, although the tonalities are the same.

Now it is time to start on the volumes and forms of the landscape. To do this you need to increase the tone of the color, adding a little more paint and dissolving it on the palette where you prepared the previous tone.

Concentrate on the middle ground and the foreground. Using this new tone you paint the shadows of the different objects in the middle ground and darken the medium tones of the foreground.

There are two basic ways of

Using a new, less diluted tone, you paint the shadows of the elements in the middle ground.

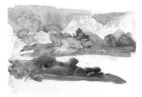

achieving dark tones in wash. The first is tone blending over the wet surface, letting the tones mix on the paper. The other is superimposing layers once the previous layer is dry, to control the resulting tones.

Transparency and Depth

This work painted by Nicolas Poussin (1594–1665) reveals his mastery of the technique of wash. The different planes lose their tonality and importance as they recede into the distance and the most distant planes are barely painted; they are just small, almost transparent stains that break up the white of the paper.

Nicolas Poussin, Wood Scene.

Defining Tones and Forms

The tonal intensity is now increased in certain wet areas of the foreground, without taking into consideration the rest of the painting. The darker shadows can be painted on dry, while the gentler tones are painted on wet, so that the tones blend together.

The shadows are the moment in which the artist truly begins to define the forms. You should bear in mind that in the wash technique tonal variation through contrast is most important, i.e., you can make a dark tone appear to shine by surrounding it with an even darker tone.

Lastly you paint the darkest areas, using the reserves to create points of light. The contrast between these light areas and the shadows is more intense the lighter the area, and vice versa.

One way of defining the forms in wash, as seen here, is to stain the main volume with a very light wash, leaving in reserve the areas belonging to the lightest grays and whites.

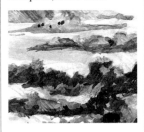

Over the wet grays, you add the darker tones, always on an ascending scale, that is, evaluating the lights in contrast to the darker grays.
This is a quick sketch, so the artist has concentrated on the atmosphere, not the detail.

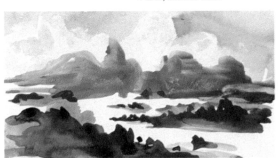

MORE INFORMATION

• Wash, a preparatory technique **p. 20**
• Watercolor and wash **p. 22**
• Basic watercolor techniques **p. 36**

ELEMENTS OF THE LANDSCAPE. SOLUTIONS

A landscape may contain a vast number of elements that are treated differently according to their distance and their place within the whole. A tree or house may be painted in the foreground, but the same object will vary in accordance with the two factors mentioned above.

Groups of Trees

There are many ways of painting trees. Watercolor uses two approaches: one is more undefined and less formal, using the wet on wet technique, while a more detailed version requires using the dry technique.

Trees in a group tend toward chromatic and formal unity, but can also be painted in more detail, for which you must wait for the background to dry and from then on use a finer stroke.

The tonality of the background is established with another, darker wash for the branches in shadow.

The brushwork is applied on the dry background using the reserves to create texture.

Synthesis of a group of trees on wet paper.

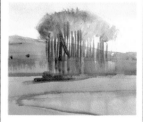

Detail in a group of trees on dry paper.

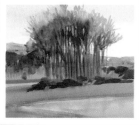

Tree Trunks

There are many ways of painting tree trunks. First, those in the plane nearest the observer require more detail than those in the distance. Detail in watercolors is obtained by means of the texture and the lights.

After dampening the area outlined by the drawing, the area of the branches is darkened; once dry, colored brushstrokes can be applied to

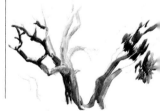

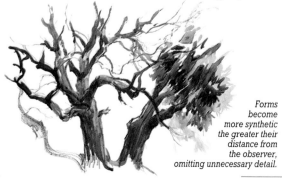

Forms become more synthetic the greater their distance from the observer, omitting unnecessary detail.

the trunk, creating the texture of the bark.

As the trees recede into the distance, the effect of synthesis should increase, meaning that the colors should blend together on the dry background, slightly increasing the darkest tonalities.

Painting Treetops in Reserve

Trees do not always appear as a mass of color against a light background. The background is usually darker than the tree itself, in which case the top of the tree must be the result of a reserve.

The lightest color is left as the reserve for the light, while the shadows are resolved by superimposing different colored washes.

Architecture and Volume

In order to paint different architectural volumes, you

The Theme of the Landscape

Watercolors are extremely transparent, enabling you to produce subtle glazes. The theme, however, should always be kept in the foreground. In this case, the motif is the sky; the low horizon of land was done last using darker colors

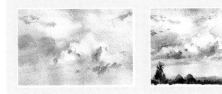

need to understand the tones and values. Therefore, it is advisable to prepare preliminary work with a wash.

The lightest walls are left in reserve, while the other walls that receive less light have a darker tonality.

To prevent the different layers from running together, you must wait until each glaze has dried first.

Once the chiaroscuro of the wash has been completed, the watercolor can start, using tonal variation with the chromatic range you have chosen for the background and the buildings.

A treetop can be laid out using a reserve.

Gentle washes are used for the less luminous areas.

The darker planes are painted, leaving the lighter ones in reserve.

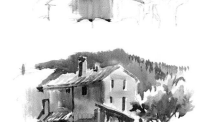

Light glazes can be used to vary the more luminous tonalities.

MORE INFORMATION

- Synthesizing landscapes in watercolors **p. 76**
- Applying techniques **p. 78**

DIFFERENT PALETTES

Watercolor is not a limited medium. Its pictorial potential is vast, as is the chromatic range it offers. As with other wet pictorial mediums, the mixing of colors within a given range produces a wide harmonic range of color. The chromatic spectrum covers the warm range, cool range, and neutral range. Using these chromatic possibilities, different versions of the same theme can be painted.

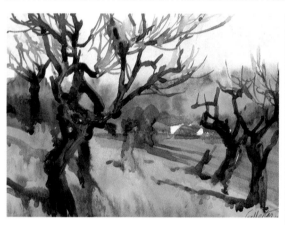

A warm chromatic range also admits cool tonalities.

Warm Chromaticism

Any chromatic range can be used in watercolor. In addition, colors from other realms can also be included, provided they do not interfere with the chromatic range in question.

The characteristics of this medium allow the background color to breathe, so a warm chromatic scale can be used although the background has previously been stained using cool colors.

Watercolor also allows you to add glazes, so a warm-colored wash can have a cool tendency once the background has dried.

In the warm palette all the colors from a yellow-orange tendency to crimsons and umbers are present, though cool tones are also included to vary certain colors.

The Cool Palette in Watercolor

Cool colors are those in the chromatic scale formed by greens and blues. Watercolor allows you to choose the color from any of the chromatic ranges used. A work may be painted entirely in cool colors as can be seen in the landscape below. In this case, warm colors have been used to create the violet-colored shadows. A cool palette is particularly useful for wet landscapes, remembering to use the white of the background as an integral part of the chromaticism used.

The cool palette covers the entire chromatic range, from yellow through the darkest blue. Warm colors are also used, for example, to bring out the violet tones as shown here.

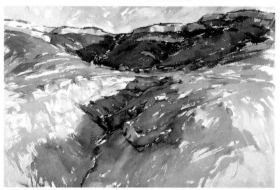

A landscape painted in the cool range.

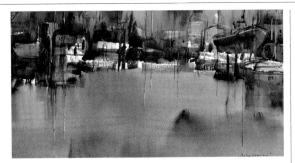

A neutral range with many cool and warm hues.

A Varied Palette

The neutral palette covers both warm and cool colors. As white does not exist in watercolor, the white of the paper is used.

To paint a landscape in this chromatic range, pure colors are not used, not even when mixed with other colors of the same range. Warm colors are mixed with small amounts of complementary colors, creating neutral colors of a warm tendency. The same procedure is used to obtain neutral colors of a cool tendency, mixing blues and greens with warm colors, but always in amounts smaller than the dominant color so as to maintain the palette within the same, neutral range.

For example, if turquoise is mixed with a small amount of English red, the resulting color will still be blue, but with a brownish tint; if a small amount of watery green is added to orange, you obtain a warm ochre.

Mixing Colors on the Paper

The Impressionist painters showed how colors could be interpreted in synthesis and how two juxtaposed colors create the impression of a third color to our eyes.

Watercolors can maintain an even chromaticism if the colors are applied on a prior layer of glaze. For example, a yellowish glaze will influence all the colors that are added later on, as they are transparent.

The landscape shown at the bottom started with a yellowish glaze. Once it was dry, the darker colors that form the reserves for the treetops were added. Over this yellow background color, the color of the fallen leaves, some small, transparent, orange and greenish brushstrokes have

Impressionist painting uses a free, clean brushstroke, often mixing the colors on the paper itself.

Chromaticism and Harmony

David Cox (1783–1859), painted *The Old Church and Clapham Community* with a highly refined technique and using only a palette of cool colors. Even so, the green colors of the treetops, the tree trunks, and the earth in the foreground have a subtle warm tendency, a tonality selected when he first conceived the work.

been added that absorb the background color, creating an overall chromatic effect that makes the colors vibrate.

Mixing the color directly on the paper is ideal for making sketches, as the colors are synthesized more readily, creating new values out of the primary or secondary complementary colors. In this example you can see how violet was obtained from blue and red, and grayish from red and green.

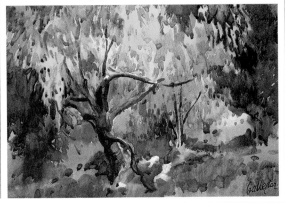

MORE INFORMATION

· Color theory applied to watercolor **p. 26**
· Great watercolor themes **p. 28**

TECHNIQUE AND PRACTICE

SYNTHESIZING LANDSCAPES IN WATERCOLOR

Watercolor is one of the best mediums for synthesizing forms. In order to paint a good landscape, the theme has to be understood as a whole. So how do we go about synthesizing a theme? It all boils down to knowing how to discern the most important elements from the less significant ones, as well as understanding which colors are most appropriate for the theme and which ones would ruin the picture.

A well-constructed outline expresses the model by means of the most essential lines.

tic of watercolor, the painter should construct a solid structure, although it should be delicate and subtle enough for the lines still to remain visible through the colors added later.

The Synthesis of Forms

The artist has to reduce the elements of the model to rough geometric forms. A good draftsman will condense the landscape to a minimum of shapes.

A wood, for instance, could be represented by a series of different colored stains grouped together in a mass and with an outline defined by a single uniform line; likewise, the rest of the shapes can be synthesized by making general groupings from individual elements.

A few simple stains may help understand the forms.

A wood can be reduced to a mere stain. Its relationship with the other elements in the picture make the spectator see it as a wood.

The Landscape Sketch

Synthesizing is the art of summarizing form and colors to the bare minimum. The artist has to synthesize the theme in order to understand it as a whole.

To synthesize a landscape on paper, the painter must sketch the most important shapes, leaving out all the unnecessary or ornamental details. This does not mean that this artist should not be rigorous in the execution of the drawing; on the contrary, due to the transparent characteris-

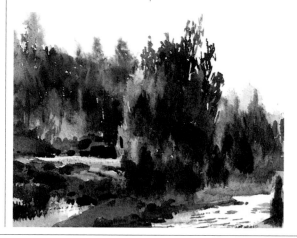

Turner and Synthesis

No one knew better than William Turner (1775–1851) the value of artistic abstractions. This picture of Venice seen from Giudecca is a perfect example of how Turner employs synthesis to evoke such exceptional atmospheres and understanding of space.

William Turner, Venice Seen From Giudecca.

When watercolors are applied on wet they tend to mix together.

Color Synthesis

The colors of reality must be transferred to the canvas. In other words, they should be summarized in much the same way as forms. Despite the fact that in reality we can see an infinite number of tones, painters have to be selective and include only those that are most representative of that part of the model they are do-

ing. Finding the right balance is not always easy and it is common to make mistakes on the paper. Consequently, we recommend that you begin with a specific palette or color range. The choice of the cool, warm, or neutral range helps to guide the painter towards the best way of synthesizing the color.

Synthesizing Techniques

The human mind remembers in synopses. If you look at an object and then immediately glance away, what is left in your memory is a summary of what you have seen. Therefore, it is useful when painting a landscape to momentarily turn away in order to recall its form and color in synthesis.

The reduction of textures occurs because objects seen from a distance tend to join together. It is precisely for this reason that when you paint objects that appear within all of the picture's planes, such as trees, rocks, and other elements in the distance, you should emphasize detail in the closest planes, which in the case of watercolor should be painted on dry paper with color glazes and always with light colors.

At a certain distance forms and colors blend together into a single mass of color in which the tones gradually increase but texture decreases; for instance, in close up the bricks of a wall can be represented by their characteristic lines, but at a certain distance these lines disappear and are substituted by a reddish earth tone.

MORE INFORMATION

- Synthesizing forms **p. 24**
- Basic watercolor techniques **p. 36**
- Developing a watercolor in practice: the landscape **p. 54**

Watercolor allows the artist maximal expression with minimal content.

APPLYING TECHNIQUES

It takes time to master the techniques of watercolor. It all boils down to learning from your mistakes. Therefore, every work you have painted should be disassembled in your mind and be evaluated in relation to previous similar works.

Applying Reserves

Watercolor painting is based on superimposed glazes and leaving blank spaces within the areas of color stains. In practice, reserves are carried out according to what the painter wants to achieve. Occasionally the artist may use masking fluid, such as in this case, which allows painting the background directly knowing that the reserved areas will not get stained.

Masking fluid is used in the painting below to reserve the tree trunks in the foreground so that details and textures can be added to them later on.

When the entire background and the details around the reserved areas have been finished, the masking fluid can be removed with a crepe eraser. Then the details and washes can be added to the pure white area of the trunks.

The masking fluid prevents the watercolor from invading the reserves and can be removed afterwards.

Darker colors border the areas reserved for lighter ones.

Reserving on White Paper

As you have seen for yourself, white in watercolor is provided by the white of the paper, for which reason it is necessary to reserve those parts of your painting that are destined to be white or to have transparent colors.

The position of the light colors indicates where the darker colors are to be situated. The reserves of light tones should be planned in advance so that the darker colors are arranged accordingly. In the work shown on this page, the brightest tones correspond to the highlights on the water in the mud puddles.

MORE INFORMATION

• Basic watercolor techniques **p. 36**
• Advanced techniques and effects **p. 38**
• Interpreting a landscape in watercolor **p. 60**

Opening up Whites with the Brush Handle

The paintbrush is not used only for painting. Its handle is extremely useful for creating texture. When you acquire a certain amount of practice you can make scratches while you are painting.

The technique of using the handle of a brush to open up whites can only be done on

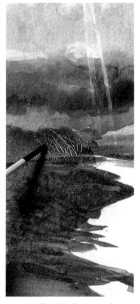

Graphic designs achieved by brisk scraping.

fresh paint. Here, the artist has designed grass by energetically scratching the damp surface of the paper to bring out the whites from under the paint.

Synthesizing Landscapes in Watercolor
Applying Techniques
The Seascape. Highlights and Contrasts

79

Scraping with a Knife

This technique is popular with professionals for obtaining specific zones of light and delicate lines. The watercolor must be absolutely dry to carry out the procedure. A white is opened up by running the knife over the paper with just enough pressure to remove the paint without damaging the paper. As you can see, the knife has to be held at an angle so that it scratches instead of cutting the paper.

Another useful method is to scratch an area repeatedly in order to create a texture in which the underlying color acts as a contrast to the pure white.

Working on Wet

A wide variety of textural effects can be created while the watercolor is still wet: you can blot part of the color with a rag

Flicking paint over the surface using a brush.

or absorbent paper and thus an imprint of the material in that area, or flick paint with a brush over a previously wetted surface, which produces a texture of tonal variations that are almost blended with the base color.

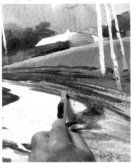

Whites can be opened up by scraping with a knife.

The cloth can be used to absorb color and leave its mark on the paper.

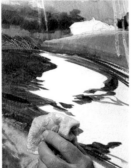

Techniques and Craft

The application of several techniques can be appropriate for any theme. In this landscape, the painter has used basic watercolor techniques.

The clouds were opened up by absorbing the recently painted color with a dry brush.

The sky was painted on wet.

The texture of the tiles was painted on dry.

The whites were reserved with masking fluid.

The wood was painted on wet and blended with the background.

These lines were opened up using a knife on dry.

The whites here were opened up with the handle of a brush.

Reserve of white from the paper

The color was absorbed with a cloth.

The texture was created by spattering.

THE SEASCAPE. HIGHLIGHTS AND CONTRASTS

Since seascapes are volatile, certain difficulties arise when painting them. The artist must spend some time studying and practicing the movement of water in order to convey it.

The Background of the Painting

Even more than a landscape, a seascape is composed of a large area filled with points of light.

By this stage you will be well aware that the transparency of watercolor is based on an initial base color that keeps breathing through successive layers of darker tones.

While the surface of the paper is wet, you can add all tonalities. The brush is used to ensure that the colors do not invade those areas reserved for the luminous spots.

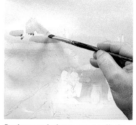

Background planes are applied on wet with almost transparent glazes.

Dark Zones as Contrast

The background is painted with a very thin glaze, and then is left to dry so that the next color applications do not become mixed with the background but appear distinctly.

Starting with the horizon area, successive glazes with sequenced tones are gradually added as we approach the foreground. The artist alternates blue with violet over the surface of the water, giving form to the shadows of the objects that are found floating in the sea.

The last zones will require nearly transparent washes, which will become more intense in the foreground

The darkest zones represent the shadows of objects floating in the sea.

A wide brush is used to spread the tonalities that are gradually added.

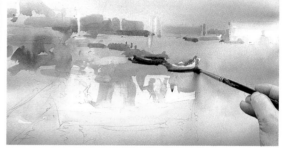

The background of the seascape is painted with light colors, thus allowing the form of the bright zones to be modeled with a dry brush. The lightest areas have been reserved.

The blues and violets are intensified in the foreground.

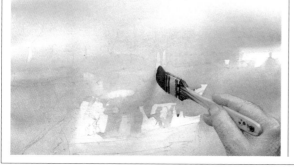

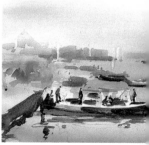

Applying the Techniques
The Seascape. Highlights and Contrasts
The Nude

81

Enhancing Highlights by Means of Dark Zones

Light colors appear even lighter when they are situated next to dark tones. Therefore, several brushstrokes are applied to represent shadows and swells in the water. These dark tones must not be painted with only one color, but by alternating two tonalities to create several planes of depth in the swells of the water.

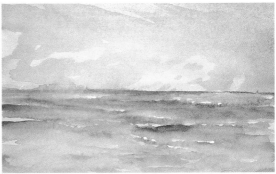

The glazes have been applied successively after completing a series of reserves: first one glaze was followed by a darkening of the tones, then it was left to dry, then another glaze was applied with more darkening of the tones.

The swell and shadows in the foreground have been resolved by drawing them.

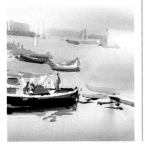

of the picture and another.

These zones have to be established from the very beginning of the painting; in the case of a large surface of water, an initial glaze can be applied in a general manner, without reserving anything except those parts that are intended to be lights and foam on the surface of the water.

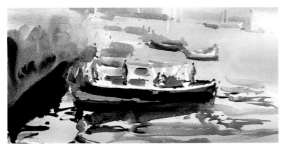

Two different tones have been used in order to alternate qualities of highlights and contrasts.

Lights Through Watercolor

One of the most important aspects of this theme is that of the lights and the foam that define the texture and state of the sea.

The highlights are obtained by means of color gradations and breaks between one zone

A grayish blue gradation can be employed over the entire paper.

Atmosphere in a Seascape

Atmosphere in watercolor is achieved by adding transparencies. Given the fact that we must always commence a watercolor with a light color, the tones and contrasts are heightened as the painting develops.

Approximation and Movement

When you paint a seascape, it is essential to take full advantage of highlights and contrasts. In this image, you can appreciate the different layers of glazes applied to create this choppy sea. The seascape should not consist of simple expanses of water; additional details should be included on the surface to express natural movement of the water.

MORE INFORMATION

• Chromaticism and depth **p. 64**
• Elements of a landscape. Solutions **p. 72**

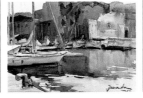

The highlights in the water are treated as breaks in the color of the darkest zones.

THE NUDE

The nude has always been a source of inspiration for many great works, sometimes for religious or mythical reasons, other times for the challenge of interpreting the human form. The nude presents the artist with considerable difficulties in composition and the rendering of lights and flesh colors. Thanks to its transparency, watercolor allows the artist to paint luminous and lifelike flesh tones.

A preliminary pencil sketch helps to allot colors to the different parts of the body.

The Fast Sketch

The construction of the human figure in watercolor can be carried out in two ways. One method entails drawing lines with a brush in order to define the figure in the same way we would draw a building, that is, constructing the parts according to the bone structure. This type of fast color note requires much practice, but, with persistence, you will do it more and more quickly. The other method is to model the parts of the body through stains.

A good way of starting a nude is to first make a basic drawing containing several quick lines that indicate the

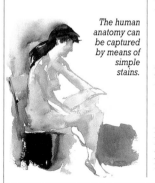

The human anatomy can be captured by means of simple stains.

position of each of the parts of the body.

Creating Volume with Light

Once you have outlined the shape, whether in watercolor or pencil, a first wash is applied to mark out the general zones in shadow.

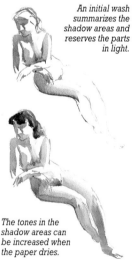

An initial wash summarizes the shadow areas and reserves the parts in light.

The tones in the shadow areas can be increased when the paper dries.

The wash will be lighter than the final result, and with it the painter can include both the lighter and darker zones, which at the moment have the same tones.

This first wash emphasizes reserves for the most luminous body areas and is done on dry paper. Nonetheless, if you can foresee darker areas in your

work, you can direct a greater amount of watercolor toward them. Look, for example, at the outside of the leg in the middle drawing.

Once this first wash has dried, you can continue increasing the tones in the darker areas.

Synthesis and Composition

The human figure can also be modeled by color. To do this, we must draw a sketch of the body and apply a first glaze of the color from which to work.

The first color alterations are carried out on the wet paper, adding chromatic variations in the zones in shadow, modeling the brushstrokes, and making sure the stain does not spread into zones destined for lights.

You must take into account the effect of new colors blending together over a wet surface.

Once the figure is drawn, a thin glaze is applied over it and the first color is painted on top.

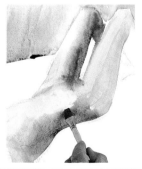

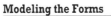

The Nude and Expression

Although this nude painted in watercolor does not have a big chromatic variety, what really makes it stand out is the drawing and the glazes painted on dry over the torso and the arms.

Egon Schiele,
Seated Girl.

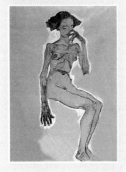

Modeling the Forms

Once the painted zone has dried, an ultramarine blue glaze is used to outline the shadow. This glaze is painted in one single stroke down the shaded side of the body.

The arm is finished off with a somewhat cooler flesh color, opening up the shine with a dry brush; a warmer glaze models the thigh. The painter takes advantage of the color change to paint some sienna in the hair.

A blue glaze is applied along one side of the body.

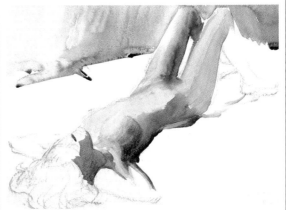

The entire nude has been painted with brushwork that follows the direction of the limbs.

Once the body has been resolved, the rest of the anatomy is expressed by alternating glazes on dry.

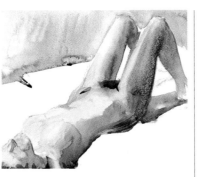

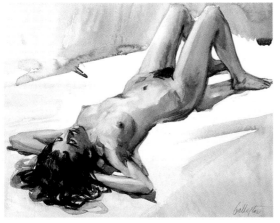

Creative Possibilities

Among the different creative possibilities of watercolor, nude painting lets you take advantage of various techniques for opening up whites to enhance the highlights in each of the body areas.

Skin luminosity should be planned beforehand with the first glazes. However, even when the picture is dry you can add highlights by dampening the zone you are attempting to lighten and absorbing the water with a dry brush. Another very rapid method of opening up highlights is to wet the zone you want to lighten with a mix containing 50% water and 50% bleach.

MORE INFORMATION

• Great watercolor themes **p. 28**
• Basic watercolor techniques **p. 36**
• The portrait **p. 92**

AIRBRUSH PAINTING

The versatility of watercolor allows its application in all fields of art. Generally speaking, the airbrush is used solely in illustration and design, but the number of painters who choose to work with this instrument increases by the day. The airbrush can be employed with any type of liquid paint, for which reason watercolor is a particularly ideal medium.

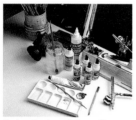

Basic setup for painting with an airbrush.

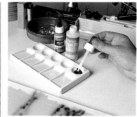

Mixes in liquid watercolor are carried out on the palette.

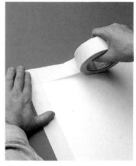

A mask made with adhesive tape.

Accessories and Tools and Their Use

You will need the usual watercolor painting accessories plus an airbrush, a can or a tank of air propellant, and a mask for reserving.

Watercolor is an excellent medium for painting with an airbrush, but within the range of watercolor paints available, the most appropriate is the liquid watercolor-type, which comes in bottles containing a dropper for controlling its dosage.

Liquid watercolor must be mixed in pans. The desired amount of each color is mixed in a pan and is then loaded into the airbrush using the dropper. Once the airbrush is loaded, the paint pressure should be tested on a piece of paper.

Basic Techniques, the Mask

Liquid watercolor is one of the most popular mediums used with airbrush. When artists paint with watercolor and airbrush, they have to use masks to protect those areas they want to reserve.

Each of the different types of material used for making masks possess their own particular characteristics when used with propellant paint.

Testing the color and the air pressure.

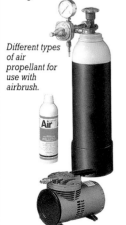

Different types of air propellant for use with airbrush.

The paint is sprayed over the desired area.

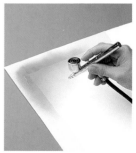

Transparency and color superimposition are characteristic of the watercolor medium.

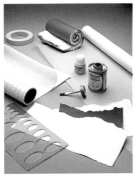

Materials for making masks.

Once the area has been painted, the mask is removed.

Basic Forms

Airbrush usually is applied to zones that have been previously reserved. In this way, the artist can paint geometric forms by playing with the direction of the light and the intensity of the watercolor when applied with

The reserve allows the shape to be isolated while working on the areas of lights and shadows.

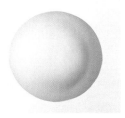

Masks and Glazes

To paint this work the artist Shiro Nishiguchi had to make masks for each one of the closed areas, that is to say, one for the shape of the fish, another for the water, another for the fish's different parts, etc. When the fish was finished, the painter applied a glaze in airbrush in the area above the tail, the zone farthest from the fish.

an airbrush, creating gradations that produce areas of lights.

Likewise, by taking advantage of the watercolor's transparency, it is possible to superimpose transparent planes.

Watercolor allows the overlay of airbrushed planes.

MORE INFORMATION
· Advanced techniques and effects, **p. 38**

Painting Geometric Forms

All elements can be reduced to basic geometric forms; therefore, it is useful to practice them so you will be able to paint more complex shapes later on. To paint a cylinder, first draw the shape on a mask and attach it to the paper. Cut out the oval shape, which reveals the inside of the cylinder, and keep it to one side. Now paint the oval area with a gradation made of lines that run in the same direction as those that shape the cylinder. Once the color is dry, place the oval mask over the painted area.

Now cut out the rest of the cylinder and softly shade in the darkest zone. Finally, paint the highlights and shadows with the aid of a ruler and following the shape of the cylinder.

A gradation over an "unmasked" area.

The ruler is used to mask the straight lines and highlights.

After painting the whole cylinder, masks are removed.

TECHNICAL APPLICATIONS IN ILLUSTRATION

IIllustrators have always used watercolor for their works. The application of the medium in this field does not differ much from the way it is used in paintings. The most significant difference lies in the themes, even though it is true that many professional illustrators produce such individualistic work that they end up adapting the medium to their own needs.

Image and Background

In the same way you would tackle any other theme in watercolor, the illustration requires a concrete drawing. However, frequently, the background is resolved independently of the main figure.

It is common to draw the figure and then reserve the zones it occupies before painting the background, or even to paint the background in order to open up whites later on in the

The drawing must be quite detailed.

The background is painted over the drawing, leaving the pencil lines visible through the airbrushed paint.

areas that will be occupied by the figures.

In this case, the artist must begin with a very detailed drawing and then paint the background in watercolor with the airbrush. Once the sky and the gradations in the sea have been completed, the whites in the figure can be opened up.

The seagulls are brought out by absorbing the paint with a brush. The girl is opened up with the brush and a mix of water and bleach.

Whites are opened up to define the figures, absorbing paint with washes in the case of the seagulls and applying water and bleach in the area occupied by the girl in order to obtain a bright white.

The brightest zones are obtained by washing the zone in question several times.

Foreground and Middle Ground

When you have finished opening up whites to situate the illustration's figures, you can paint the darkest zones, located at the bottom of the picture, which you wet before applying the green of the trees.

The crests of the waves were effected with a mix of bleach and water, using blotting paper to absorb the paint.

The whites of the waves are opened up by wetting the area and then absorbing the paint with blotting paper.

Painting the Figure

An illustration should have something specific to say. Therefore, the characters who develop the story should be well defined, and rendered sharply and didactically. This requires that the drawing be developed meticulously.

It is best to paint the flying girl in parts, so each area has to be clearly marked out. You should allow each area to dry before staring on a new color. The painter can develop all the necessary tonal variations within each determined zone;

for instance, the pinkish tone of the shirt has been intensified here, and two distinct tones have been achieved in the hair.

The Finishing Touches

The finishing touches are vital, since the result must be clean and precise. The adhe-

The figure is painted by parts, allowing each one to dry before embarking on the next.

sive tape is removed from the sides, leaving the illustration perfectly framed in white. The remaining work on the girl is carried out with watercolor pencils, which allow the strokes applied with them to be blended into the background by simply wetting the

Illustration and Watercolor

Watercolor allows a wide range of possibilities within the field of illustration; from drawings designed for illustrating children's stories to those in the most ironic cartoons.

The line and color are more predominant in illustrations than in a purely pictorial work.

The illustration may contain certain pictorial connotations, alternating a linear quality with the different effects that can be achieved with the watercolor medium.

line with a brush.

Finally, the girl is outlined with a fine line of color and the facial features and hair are painted. Once the girl is finished, the same technique is employed on the seagulls, which are outlined in blue.

MORE INFORMATION
• Basic watercolor techniques **p. 36**
• Advanced techniques and effects **p. 38**

Once the colors have been painted, the girl and the gulls must be cleanly outlined. Good definition is essential.

When the figure is finished, the lines are dampened in order to soften them. Thus, they become soft shadows.

TECHNIQUE AND PRACTICE

GLASS AND HIGHLIGHTS

Highlights and reflections are difficult to resolve in any medium. Both a mastery of the medium and drawing are necessary to obtain the effects of light on objects without distorting their shapes. Watercolor is particularly apt for producing highlights, but not by really painting them, since they are always represented by the white of the paper. In other words, the highlights are already there, all we have to do is paint what surrounds them.

Highlights and Contrast

Whereas in any other medium the need for white color would require using white paint, in watercolor the white of the paper is reserved for the white color. In fact, the whites obtained in watercolor produce as interesting effects as the white paints of other pictorial mediums.

A color always appears lighter when it is situated next to a darker one. Therefore, color is to be worked to create an atmospheric effect between the object represented and the

spectator, and the chromatic intensity will make the sheen reflected in the object appear either more or less luminous.

Glass Highlights and Color

Glass, unless it is stained, is colorless. Its transparency makes it acquire chromaticism from the colors that are situated around it.

On the other hand, since watercolor lacks opacity, it is not possible to paint light colors on a dark background.

It is for this reason that glass is painted by gradations of the color and with the reserves in the surrounding area.

Painting a Glass Object and its Highlights

In order to paint glass, you should begin with a finished drawing that has the highlights

clearly marked on it.

First you paint the entire area surrounding it, leaving in reserve the space that the glass object occupies.

Once the paper is totally dry, a first glaze of the same color as the object is applied, reserving the zones of maximal light and laying tonal gradations in the curvatures, such as the neck of the jug.

When the first glaze has dried, a second darker wash is used to enhance the shaded areas, the surface of the liquid, and the parts next to the highlights to emphasize their brightness and create a contrast in the different volumes.

The reflected highlights in the two objects are identical since both are obtained from the white of the paper; nonetheless, the first appears less bright due to the fact that the contrast between the highlight and the adjacent color is less pronounced than that of the jug in the second picture.

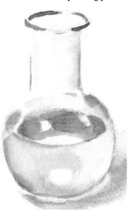

The painting must begin with a perfectly defined drawing, with the highlights clearly indicated in their corresponding places.

Glass and Color Background

When a glass object is placed on a colored ground, the light gives the highlights contrasting tones; on the other hand, the glass object allows us to see shapes but with the distortions that its surface (concave in this case) transmits to the spectator.

A glass jar situated in front of a two-color background allows it to be seen, but in a distorted manner. Therefore, the effects of the distortions must

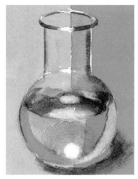

Each one of the color zones has been painted once the background has dried in order to avoid unwanted color mixes.

be designed beforehand so that they can be painted with the required precision. You should always paint the lighter parts first and leave the dark grays that create the contrast for later. The brightest of the highlights can be executed by washing the area with a mix of bleach and water.

MORE INFORMATION
- Basic watercolor techniques **p. 36**
- Advanced techniques and effects **p. 38**
- Still life: the model **p. 44**
- The seascape. Highlights and contrasts **p. 80**

The Maximal Contrast in Highlights

When a glass object is placed in front of a dark or black background, the object can only be represented by its highlights. To capture an object

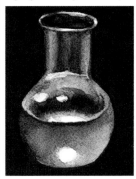

under these conditions means that the artist must do an accurate drawing to use as a guide in order to avoid making mistakes during the painting stage.

The background is first painted with the darkest color; once it is dry, using the same color, a glaze is applied within the object. This will ensure the white reserves, which represent the brightest points, are not painted over. Then the background color has to be gradated toward the brightest parts, leaving to the end the work of opening up any extra white with water and bleach.

The tonal gradations and highlights (reserves or opened up whites) bring out the volume of a glass object on a dark background.

The Color of Gold

Gold as a color does not really exist. Gold is composed of a whole range of shades from colors reflected upon it. Yet it is possible to approximate gold using a series of yellow and ochre glazes. In this

case, it is very important to establish the highlights...after all, in painting, a metal without highlights or reflections would not be metal.

A color range used to paint gold objects. It is the highlights and reflections that make a gold object look golden.

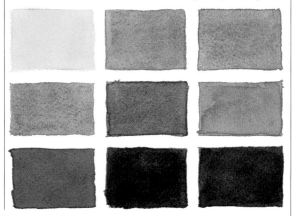

NOTEBOOKS AND SKETCHES

Good watercolorists obtain practice from preliminary works rather than those they show to the public. The more delicate a watercolor painting is the more elaborate the technique employed, and it is often in sketches where this elaboration can be perceived. Indeed, the most valuable work is often hidden in the notes and sketches drawn by the painter in notebooks. It is interesting and necessary to sketch as often as possible; this way your studies will gradually acquire more fluidity and your finished pieces will show the development of your skill in synthesizing.

The notebook allows the painter to compare different points of view of a single theme.

Minimal Materials

You should always carry a small painting kit, because you never know what you might come across. A good idea or a small color note can later be the basis for a definitive work. All you need is a small paint-box and a brush. A water container can be improvised from

Small paintboxes are available that fit perfectly in a pocket.

In addition to a small notebook, the artist should always carry a box-palette. Any other materials can be improvised on the spot.

a paper cup or the cap of a bottle. It goes without saying that you also need a notebook to draw and paint your notes in color. The quality of a notebook depends on the paper. It is best to buy notebooks that contain relatively few pages but are of adequate weight and sizing.

The Advantages of Sketching

One of the benefits of sketches is that they allow you to see the possibilities of a subject no matter whether you do them in color or in pencil.

Sketches provide a spontaneous, overall view of the scene; and it is precisely this

on-the-spot examination that makes a sketch or a color note so valuable.

It is a good idea to make at least two roughs of the same subject, although not necessarily in color, because your first goal is to locate the most appropriate viewpoint for the final work. Once you have made your choice, the sketch will be a good reference and then, you can concentrate more on the colors.

Once the fit has been chosen, the sketch can be used as a chromatic guide.

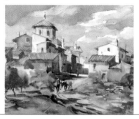

Glass and Highlights
Notebooks and Sketches
The Portrait. Techniques

91

Sketching the Surroundings

Rough sketches should be executed in as fresh and spontaneous a manner as possible. Ideal subjects for color notes are places where people tend to congregate in large numbers, such as markets, where local color and the many different activities provide an infinite number of artistic possibilities.

There are several ways of handling a crowded place: one method is to draw a scheme of the architectural elements and then place people within it. Another way is to draw groups of people and the general colors of the whole scene, and

Wash can be used to capture in a fast and concise manner landscapes and their values in the form of gray tones.

The painter can make a general sketch of the architectural and human motifs.

then integrate the sketch into a future painting.

Sketching and Abstraction

Notes have to be explicit but concise; in fact, it is in the

A watercolor sketch of a crowd of people. Some notes are painted with a two-color wash.

Sketches can be later incorporated into definitive paintings executed in the studio.

sketch that the artist makes the greatest effort to synthesize the theme.

As its name suggests, the quick color is executed straight away, without giving the different colors time to dry.

This means that, since the colors will mix together, you must ensure that you condense everything you see.

This effort of synthesis in order to reduce forms to the minimal comprehensible expression often leads us to the idea of abstract work.

The aim of this sketch is to highlight the diagonal composition obtained from the volumes and the perspective.

Sketch in which the artist tried to capture the rainy atmosphere through the reflections of the human figures on the water.

A sketch of a landscape in which the different planes are distinguished by their chromatic variation within an almost abstract rendering of the actual scene.

Delacroix's Small Studies

Work done in notebooks has been a source of inspiration for many artists; in fact, the type of quick design painted on a trip, or an excursion may turn out to be of great value for use in later work. During a trip to North Africa, Eugène Delacroix (1798–1863) executed numerous watercolor notes concerning people and places. This *Album of Sketches of Morocco* provided the groundwork for numerous definitive paintings.

MORE INFORMATION
• The studio and materials for watercolorists **p. 10**
• Paper for watercolor **p. 14**
• Preparing the paper **p. 16**

THE PORTRAIT. TECHNIQUES

The watercolor medium can be used to paint any theme. Nonetheless, due to the fact that watercolor cannot be rectified, the portrait is one theme that watercolorists tend to avoid. This does not mean you cannot paint good portraits with this medium. All you need is to practice the theme until you begin to master it with precision.

Features and Proportions

Within the plastic possibilities that this medium has to offer, the portrait theme can be resolved with a formal perspective or with a personal and expressionist treatment.

Both the portrait and the self-portrait require careful synthesis in the painting and a sound anatomical knowledge of the face and the head.

When you paint a watercolor the volumes are understood by the highlights and whites. The model must be analyzed as a series of planes that recede or advance on the curved shape of the face. The correct distances have to be calculated between the features of a face and the surface on which they are situated.

Color and Light

The painter has to consider the structure of the head and the direction and intensity of light from the very moment work starts on the face.

An expressionist treatment allows the painter to synthesize the facial features by means of stains that do not necessarily have to be in a warm key. Bear in mind that, due to its transparency, watercolor allows a superimposition

The portrait must be painted with a sound knowledge of the shape of the head and the direction of the light. The glazes serve as a foundation for situating the darkest colors.

of glazes so that it is possible to tone a bluish glaze with a warm one, without forgetting that it is not possible to paint light colors over dark ones.

A portrait can be begun by situating the two basic light zones, understanding the warmest as that corresponding to light.

Volume and Features

Once the zones of light and shadow have been established, the subject's features have to be represented.

First we have to situate the eyes and the eyebrows, indicating thus the symmetry of the face. Darker colors are used here since there is no need to paint light colors over them.

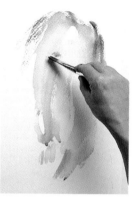

Marking in the eyes in order to use them to establish the other facial proportions.

The distance between the eyes must be correct. Closely observe the distance on the model and then translate this measurement onto the paper. Scale is everything.

Once the eyes have been situated, the other features are incorporated. Volumes are obtained by situating a dark tone next to a lighter one; this is how the nose has been resolved.

MORE INFORMATION

• Watercolor themes **p. 28**
• Advanced techniques and effects **p. 38**
• The nude **p. 82**

Notebooks and Sketches
The Portrait. Techniques
Watercolor. Abstraction and Experimentation

93

Searching for a Likeness

The likeness is not apparent from the start. It is achieved gradually as the painting develops. Once the shadow of the nose has been painted, you can scale the whole nasal structure in the center of the face.

The width of the mouth is determined by establishing the distance from the position of the eyes; of equal importance is the space between the nose and the upper lip.

Once the spaces between the different features have been resolved, we can begin to work on the likeness by adding the different elements that characterize the face, such as a beard, hair, glasses, etc.

The artist begins to search for a likeness once the distances between the different features have been established. The brightest areas are reserved as the features are detailed with dark colors.

A Variety of Styles

With watercolor you can adopt any pictorial style. You can paint both on wet and on dry, the combination of which allows you to achieve subtle blends in the gradations of shadows and the large areas of uniform color.

The creative possibilities of watercolor can be obtained with free sweeping applications of flat color.

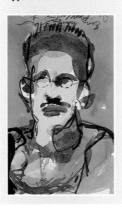

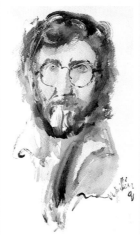

When the main features have been painted, a likeness is obtained by including those features that are most characteristic of your subject.

Glazes for Obtaining Color

Another method for painting a portrait is by means of color glazes. This type of watercolor requires a very detailed drawing, so that errors can be avoided when paint is applied. In this case, the painter has to establish the zones of light and shadows in the drawing.

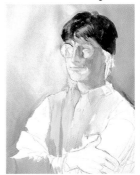

The first glazes are always brighter than later ones, leaving the whites and highlights in reserve.

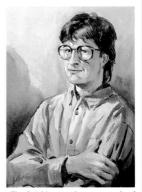

The finishing touches are resolved carefully, adding color in those zones you wish to darken and brightening the tone in the features of the face that appear too shaded.

First the lighter tonalities are painted, reserving those zones destined for the most significant highlights. Then the darker glazes are added, always reserving the most luminous area.

TECHNIQUE AND PRACTICE

WATERCOLOR.
ABSTRACTION AND EXPERIMENTATION

Pure abstract painting is the most difficult work to execute. Rarely is a work completely abstract. There are almost always some real and figurative elements. You can begin to paint abstracts the moment you feel you have mastered the medium and the art of drawing. Only when the head guides the hand and you can project your mood can abstractions be done well.

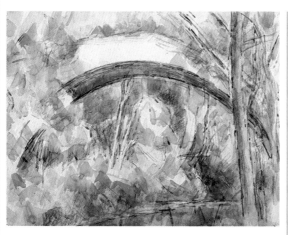

Paul Cézanne, Le Pont des Trois Sautets. *The precursor of Cubism understood that nature could be represented in many ways; in this work, Cézanne used a completely transparent watercolor and alternated green and yellow stains with a rhythmic composition of an arch and a vertical form.*

The Medium and Abstraction

Watercolor is an exquisite medium for abstract themes, since its immediacy and freshness allow artists to express their feelings with speed.

To embark on an abstract work often requires sound knowledge of figurative painting and its techniques, such as the fit, composition, and even color theory as applied to watercolor.

The artist can begin with a realistic theme and extract the most appropriate concepts and flesh them out with color stains. For instance, with a landscape, the painter may decide to abstract only the color, mixing forms by means of chromatic fusions or leaving them to mix together at random in order to compare results with other experiments.

Forms may also be conveyed as transparent masses through which successive layers can be seen.

Toulouse-Lautrec, Cocyte en la Belle Helene. *In this watercolor the artist represented the essence of the portrait in a masterful way. Only two color masses are used to define the body and the head. The simple lines that represent the other features are barely perceptible. There are no superfluous elements and the work of synthesis is perfect.*

Synthesis and Form

Abstraction does not necessarily imply a complete escape from reality. Frequently it is possible to paint a truly abstract painting by simplifying the model's apparently complex forms.

It is a question of making a mental effort to suppress the unnecessary and represent through color and form only those characteristics of the model that leave it recognizable.

Above all, observation of reality and memory are the painter's best tools for obtaining a good work of synthesis. Study your model, close your eyes momentarily, and paint only what you can recall; this is

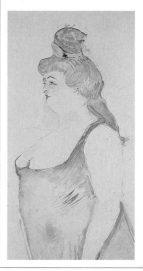

Juan Gris, Compote Dish and Carafe. *Cubism was the test bench for all pictorial mediums, such as this work, executed on wood, proves. The technique is watercolor enriched with a greater amount of pigment than normal. Avant-garde painters carried out all manner of experiments with watercolor, mixing it with alcohol, varnishes, and even with egg agglutinates (similar to the medieval medium of tempera).*

an excellent exercise for learning how to synthesize forms.

Experimenting with Watercolor

You might have believed that watercolor is too methodic a medium for experimentation. On the contrary, the gum arabic binder contained in watercolor, which allows it to adhere to the surface, means that watercolor can be applied on paper, wood, or cut paper to make a collage on cloth.

The plastic possibilities of watercolor allow it to be used alongside other mediums, always remembering to respect the rule to paint thick over thin.

A watercolor on board can be touched up with oil or varnish, and can even be alternated with acrylic.

Variety of Surfaces

Abstraction often leads to experimentation especially when you are using the paint to obtain different types of artistic results.

The painter will want to experiment on different surfaces, including primed or unprimed

Paul Klee, Love Song Under the New Moon. *Klee was an outstanding experimenter in all pictorial mediums, always applying his own special vision of art to them. In this work painted in watercolor on primed sacking, the paint adhered only in those areas where the primer had filled the pores; then the sacking was attached to canvas.*

cloth, paper, and wood, and to play with the watercolor, observing how it is absorbed more in the less primed parts, or how it is rejected if the canvas has been first painted with oil.

MORE INFORMATION
- Basic watercolor techniques **p. 36**
- Advanced techniques and effects **p. 38**

Enjoy Yourself Painting

Emotions can be expressed through a painting. Dialogues can be established between the painter and the spectator. There are many ways of understanding art, and experimentation can lead us to some of them. It is always beneficial to vary techniques and thus have new experiences in the creative process.

Ramón de Jesús, Mickey Looking at Himself with a 104° Fever. *The expressive stroke also leaves the artist's mark on the canvas. This watercolor was painted with drybrush and wet techniques, blotting,*

and the use of salt to obtain texture. It is painted on photographic plastic paper, which allows the painter to wet it as much as he requires in order to touch up.